IMAGES
of America

MONTVALE

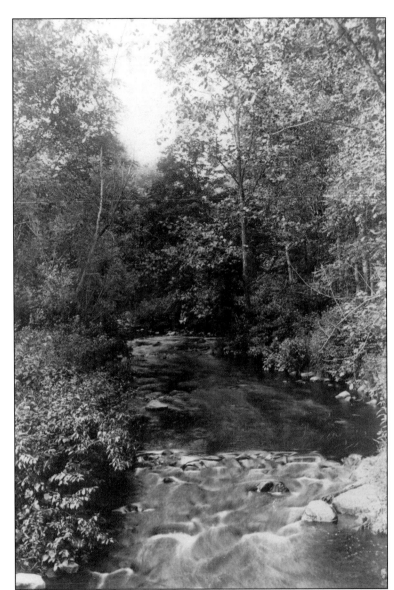

The Pascack Brook runs from north to south through the Borough of Montvale. While today it is thought of more in terms of enjoying the beauty of a babbling brook, in the past, it was a vital part of the community. It was dammed to make ponds, and its waterpower was used to run sawmills and gristmills. In the winter, ice was harvested from the frozen ponds and stored for use in warmer weather. People were fed by the trout and other fish in the brook and got their exercise by swimming in its frigid waters and skating on its frozen ponds. This photograph was taken in 1905. (Courtesy of Ronald Busse.)

ON THE COVER: This picture, taken in 1947 in Montvale School No. 2, shows Esther Renard's first-grade class. Special thanks to Vicki (Darwina Mead) Slockbower, Kathy (Huff) Bowen, Jackie Smyrychynski, Lois Ann (Papay) Uhl, and Richard Stalter for identifying their classmates. Please see page 88 for the entire picture (including three more students) and the students' names. (Courtesy of Vicki Slockbower.)

IMAGES
of America

MONTVALE

Maria Pratt Hopper

ARCADIA
PUBLISHING

Published by Arcadia Publishing
Charleston, South Carolina

Printed in the United States of America

Library of Congress Control Number: 2019943028

For all general information, please contact Arcadia Publishing:
Telephone 843-853-2070
Fax 843-853-0044
E-mail sales@arcadiapublishing.com
For customer service and orders:
Toll-Free 1-888-313-2665

Visit us on the Internet at www.arcadiapublishing.com

Dedicated with love to my grandparents Paul and Belle (Newell) Pratt, who first came to Montvale in 1900 as "summer visitors," and Julius and Marie (Bruni) Ballanco, who moved to Montvale in 1926. Also dedicated to Leigh Hopper, who came to Montvale in 1962 and has come to love my hometown as his home ever since.

CONTENTS

ACKNOWLEDGMENTS

Many thanks to all who made this book possible; without your help, it would never have been written and published.

Firstly, I would like to thank June Handera, the first borough historian of Montvale, for assembling such a wonderful collection of photographs for the Montvale Archives. Thanks also go to my late sister-in-law Cheryl (Hopper) Todd, former historian of Westwood and Washington Township, for setting the mark for excellence in the role of historian. She made 35mm slides of more than 500 pictures in the Montvale Archives. The late Helen Gartman, assistant borough historian, was devoted to researching Montvale's history and searching the newspapers for articles of interest.

To all those historians, amateur and professional alike, who have contributed so much to the understanding of Montvale's past, I thank you all. Howard Durie's series of articles on "The Sandstone Homesteads of Montvale—Past & Present," published in *Relics*, the newsletter of the Pascack Historical Society, in 1977 and 1978, were particularly helpful, as was his book *The Kakiat Patent*. To the unnamed authors of the *Montvale 1944 Booklet* and the *1994 Centennial Journal*, their work was invaluable. Former councilman Richard Voorhees has my special thanks for all the work he did on the *Centennial Journal* and particularly for abstracting the borough council minutes from 1894 to 1994; both were fabulous sources for this book.

Thanks to all who contributed photographs to the Montvale Archives in the past, particularly the late Ronald Busse and Herbert Syrett as well as Jerry Della Bella, Leigh Hopper, the Huber family, Dora Kuehkle, Claire B. Lamb, Robbie Ter Kuile, and Cheryl Todd.

Thank you to all who donated pictures and provided information for this book: Bruce Hopper, Mike Furman, Susan E. Kenney, Jeff Lange, Joe Lombardi, Heather McGee, Bette (Silcher) O'Conner, Paula Paquin, Mary Lou (Bailiff) Parodi, Vicki (Mead) Slockbower, Jacqueline Smyrychynski, Tom Schnaidt, Dorothy Waldt, Wendy Whiteside and the Montvale Evangelical Free Church, Park Ridge American Legion, and St. Paul's Episcopal Church. My apologies to those who contributed photographs that unfortunately, for lack of space, I could not use; copies of them are now part of the Montvale Archives.

Thanks to Steve McKenna my IT guy, Jesse and Ann Hopper for taking the contemporary photographs, and Dawn (Hopper) Wentworth and Peggy Litke for proofreading. A special shout-out goes to Mike Furman for making "Montvale, NJ Memories" one of the best Facebook pages ever. Very special thanks to Carolyn MacDonald for all her Montvale drawings, especially those used here with her permission.

To my editors at Arcadia, Erin Vosgien and Angel Hisnanick, you were a pleasure to work with and very patient. Thanks also to the administration and staff at the borough hall for answering my every question.

Finally, to my loving and patient husband, Leigh, who helped and encouraged me and put up with another night of takeout as the deadline for submitting this project drew nearer.

Big thanks go to the Pascack Historical Society for many pictures, cited as PHS. Unless otherwise stated, all images appear courtesy of the Montvale Archives.

INTRODUCTION

A few words about how this book was organized: I have always thought about Montvale as having four major events that more or less changed Montvale forever. The first was the coming of the railroad in 1871. Prior to that, the name "Montvale" or "Mont Vale" was unknown for our area. The eastern portion of what is now Montvale was known as Upper Pascack, or Middletown, and the western section as Forshee Town or Chestnut Ridge. This, then, is the subject of the first chapter, "In the Beginning," from Colonial times until 1871.

The coming of the railroad in 1871 not only brought summer visitors, but it also changed the center of town from the intersection of Summit Avenue and Spring Valley Road (then known as Main Street) to the area around the new train station in the eastern part of town. Prior to 1871 and for some time thereafter, the stagecoach had stopped there, and a general store was there as well. That area then began to be called Upper Montvale. Thus, chapter two is called "Montvale and Upper Montvale," and runs from 1871 until 1895. On August 30, 1894, a total of 49 of Montvale's citizens voted to separate from the townships of Washington and Orvil and become an incorporated borough. There were no negative votes, and the following day, the Borough of Montvale was formed.

The third chapter is called "Early History of the Borough," and covers the time from 1896 until 1930. Why end there? Another import event took place then: the opening of the George Washington Bridge in Ft. Lee, New Jersey, just 20 miles away. The ability to commute into New York City by car brought many more residents into Montvale.

The fourth chapter is a rather eclectic collection of photographs from "Around Town," including a section on summer, fall, winter, and spring. Most of the pictures were taken between 1931 and 2000.

The fifth chapter, "Houses of Worship," is concerned with churches that are or at one time had been in Montvale. It should be noted that, in Colonial times, the Jersey Dutch who lived in the area worshiped at either the Reformed Dutch Church in Paramus (now Ridgewood) or the one in Old Tappan, New York. After 1812, there were Dutch Reformed churches in Upper Saddle River and Pascack (Park Ridge) that they attended. The Roman Catholics in town worshiped in Park Ridge at St. Mary's, and later in a newer church named Our Lady of Mercy. The Jewish people attended the synagogue in Park Ridge, and there were protestant churches of different denominations in Park Ridge and Pearl River, New York, which many attended.

The sixth chapter, "Reading and 'Riting and 'Rithmetic," as one would suspect, deals with the education of our children over the years. Since School No. 2 later became the library, that too is in this section.

Chapter seven, "Thank You for Your Service," is devoted to the local veterans who served our country in time of war. Special tribute is paid to the seven young men who lived in Montvale and made the ultimate sacrifice to our country.

Chapter eight, "They also Serve," is a thank-you to and history of the police, fire, and ambulance corps members. The ladies of the Montvale Chapter of ACTION (American Council to Improve

Our Neighborhood) were active for almost 30 years and were responsible for many improvements throughout the town. A whole book could be devoted to thanking the many hundreds of volunteers who lend their time and talents to make Montvale a wonderful place to live, including, but not limited to, the mayors and council members, those who serve on the Planning, Zoning, or Environmental Boards, the Board of Health, the Historic Preservation Commission, the Recreation Committee, Library Board, the TV Access Group, Boy Scout and Girl Scout leaders, sports managers, and coaches. The list could go on and on, thanks to all the members of our community who also serve.

Chapter nine shows how being "The Last Stop in New Jersey" on the Garden State Parkway changed the borough of Montvale forever, and how since 1957, farmland and forests became the home of national and international corporations. So many members of our business community could not be included, since only a small portion of this book could be devoted to contemporary history.

Chapter 10 was the most fun to work on: "Annual Events and Celebrations." The photographs, taken over many years, take the reader from the January 2016 swearing-in of Mayor Ghasseli to Boy Scouts marching in the 1939 Memorial Day parade, to Santa's arrival on a fire truck on Christmas Eve. The citizens of Montvale love to celebrate, as they will be doing in 2019 as the borough celebrates its 125th anniversary.

One

IN THE BEGINNING

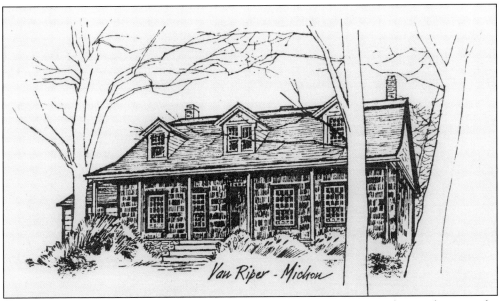

From deeds, it is known that white settlers, most of whom were Jersey Dutch, were living in the area that is now Montvale prior to the Revolution. Many lived in a uniquely American style of house known as Dutch Colonial houses, made of locally available sandstone. In the mid-1900s, there were six in the borough. Only three remain, and all are listed in the National Register of Historic Places and the New Jersey Register of Historic Places. This sketch shows the Van Riper Michon House, one of the demolished houses. (Courtesy of PHS.)

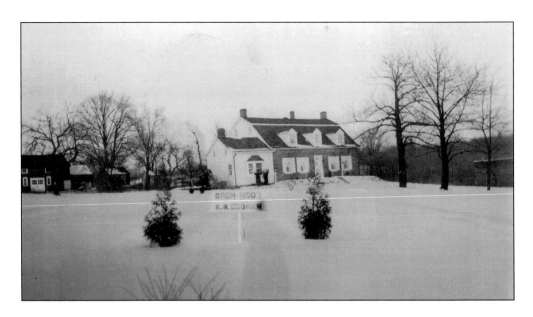

The Nicholas Holdrum–Van Houten House, on 43 Spring Valley Road, is believed to be the oldest house in Montvale. It was featured by Rosalie Fellows Bailey in her 1936 book *Pre-Revolutionary Dutch Houses and Families of Northern New Jersey and Southern New York*. According to Bailey, the house "was built about the time of the Revolution; the date 1778 is said to be cut in an attic beam." Nicholas Holdron (or Holdrum) had inherited the property in 1776. It remained in the family until 1854, when it was sold to James Van Houten. A picture in the 1936 book shows that the house was in very bad condition when purchased in 1939 and lovingly restored by Dorothy Woodward Edgren and her husband, Harold. The house is seen above in a 1944 Christmas card and below in the 1980s. (Above, courtesy of the Huber family; below, photograph by Judy Allen.)

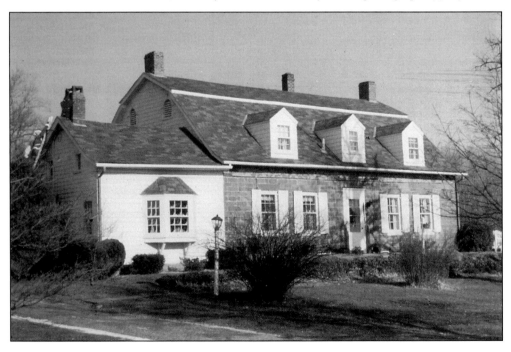

As the front of the house is no longer visible from the road, most residents are more familiar with the rear, which can be seen from Edgren Way. These three pictures of the house demonstrate the characteristics of a Dutch Colonial: it has a gambrel roof, the front of the house faces south, and the best stones were used on the front, with broken, irregular ones on the back and side walls.

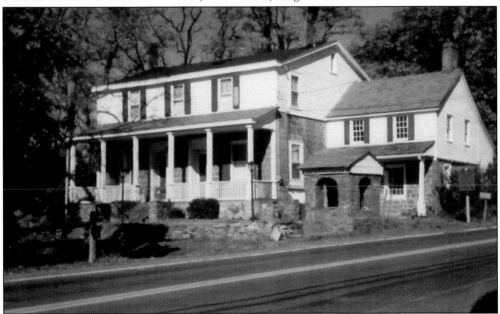

The Bergen County historical marker in front of the Jacob Eckerson house at 280 Chestnut Ridge Road reads, "Built in 1790s by Jacob Eckerson near an earlier home where he had settled about 1770. The farmstead then consisted of 119 acres. The house was inherited by his son John J. Eckerson in 1810 who owned it until 1870 when purchased by James Ledwith. The frame second story was added in the 1890s. John Foxlee bought the house and farm in 1917 and it was occupied by the family until 1971."

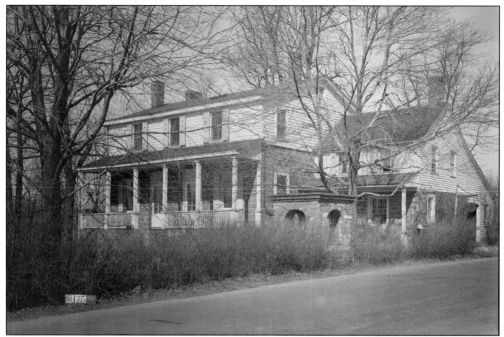

The Historic American Buildings Survey (HABS) created 17 line drawings and six photographs of this house in March 1937 but incorrectly identified it as Abram G. Eckerson's house. The drawing of the dining room features one of the two elaborately hand-carved mantels in the house; the one seen below is in the large first-floor room on the west side, and the other is in the large room in the eastern half. Houses with two front doors, as this one has, were not uncommon. The pictures were taken when John and Ludmila (Kuchar) Foxlee owned the house. Ludmila was employed as a translator and social worker by the YMCA at Ellis Island, as she was fluent in several languages in addition to her native Czech. There is a special Immigrant Aid Worker display featuring her work at Ellis Island. (Both photographs by R. Merritt Lacey, courtesy of HABS.)

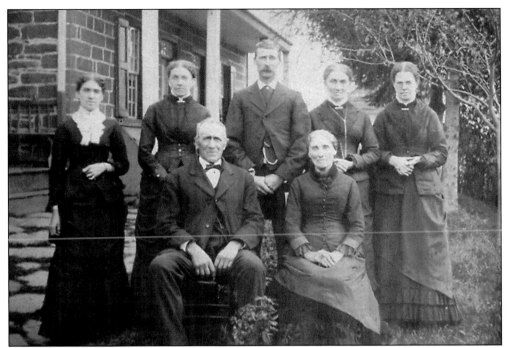

Pictured on the porch of the Forshee Van Orden House at 109 Summit Avenue around the 1890s are Thomas Van Orden, his wife Lavinia Hopper, and their five children: son Garrett (standing at center) and daughters (in unknown order) Sally, Charity, Rachel "Angeline," and Catherine. Charity married her cousin Abraham M. Hopper, and they lived in the Hopper Homestead on Grand Avenue (see page 16). The house is still located at 109 Summit Avenue, on the crest of the hill, though it has been added onto several times. As is traditional, the original regular stonework is on the front of the house, which faces south. The home has an interesting history, as it was once the headquarters of a summer camp for Girl Scouts and a stock farm for raising ducks and chickens for the New York City markets.

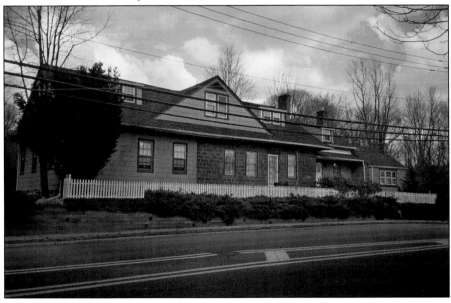

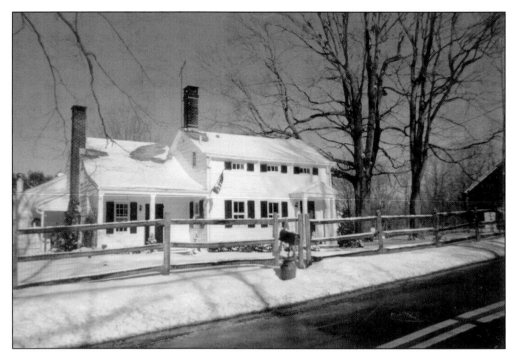

The Eckerson-Lawrence-Taylor Homestead at 205 Upper Saddle River Road was constructed about 1795 on a 34-acre portion of the original Eckerson tract by Paul Eckerson, son of David and nephew of Jacob (see page 11). The house saw few changes until 1978, when a rear addition was added, as for many years it was neglected and often occupied by tenants. There were probably over 500 Dutch barns in Bergen County in the early 19th century; there are now only about a dozen. That total includes five true form or original condition three-aisle barns. The other remaining barns were altered between the 1830s and 1875 and resulted in the Dutch/Anglo form, one example of which is the barn on this homestead, probably originally built around 1800–1820. The house, barn, and tool shed are Montvale historic landmarks.

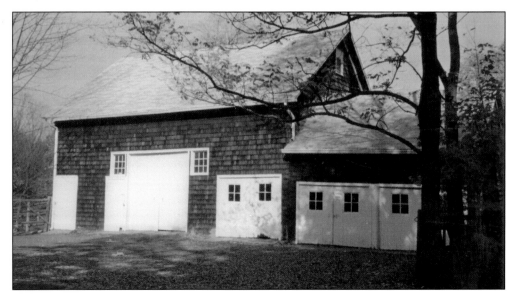

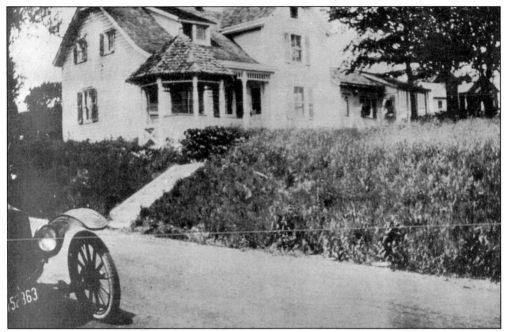

This house was built in 1812 by David J. Campbell on a one-acre lot sold to him by his father, John W. Campbell, for $30. He and his family lived in the house until 1844. At a later date, an addition to the east, dormers, and a porch were added. The house, pictured here in the 1930s, has been well cared for and can be seen at 23 Magnolia Avenue. (Courtesy of Henry and Anna Oelkers.)

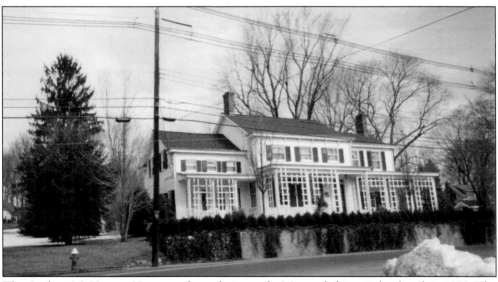

The Andrew M. Hopper Homestead was designated a Montvale historic landmark in 1998. The outbuildings, including a huge two-story barn, tool shed, well enclosure, and even the outhouse, were also designated. The added-to appearance of the house reflects the continuing occupancy through the 19th and 20th centuries by descendants of one family for 160 years; it was often occupied by several generations of a family at the same time.

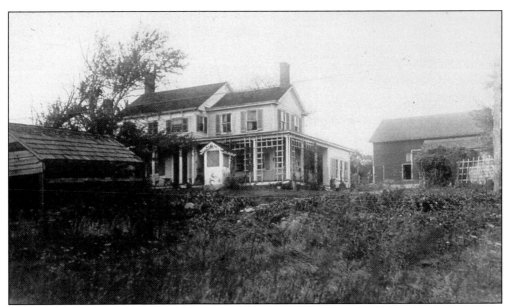

The family of Michael Hopper and his descendants lived in Montvale for nearly 200 years. The Grand Avenue property was purchased by Michael for his son Andrew in 1833, and the house was built about that time. Andrew Hopper and, later, his son Abraham, were farmers; they owned property on both sides of Grand Avenue. This photograph was taken from across the road, likely in the early 1900s.

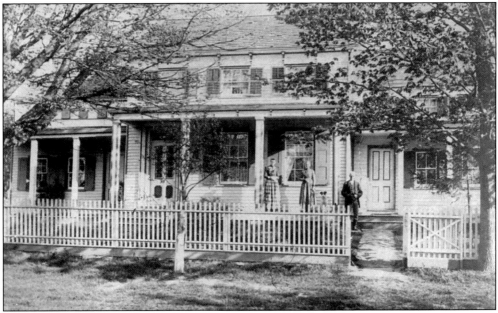

This is a photograph of Laura Hopper, her mother Charity Van Orden, and father Abraham A. Hopper. It was taken before March 1909 when Abraham died, possibly before 1900 when Laura married Robert Dickson. Dickson also died in 1909, and the two widows raised Laura's three children. Laura and her mother lived there until their deaths. Two of the Dickson children, Everett Dickson and his sister Janet (Dickson) Zibell, continued to live in the two-family house after they married.

A familiar feature at every homestead, this two-seater outhouse is thought to b the last of its kind in Montvale. According to Jim Ketels, it was a deluxe privy, as it had a wall hung with different-sized toilet seats from toddler to adult to cover the hole.

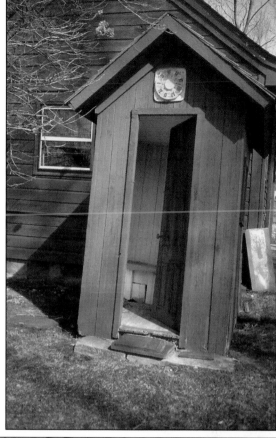

This is a c. 1930 picture of Janet Dickson in front of the well house. Note that the well enclosure has an extended roof and a wooden step, so a person retrieving water in the rain would have protection from the elements. Pictures show the well house was moved in later years, likely when the road was widened. Janet (Dickson) Zibell lived in the homestead until shortly before her death in 1996.

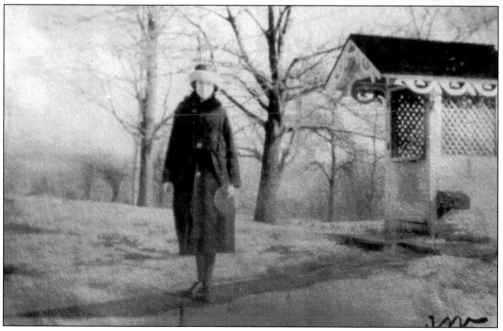

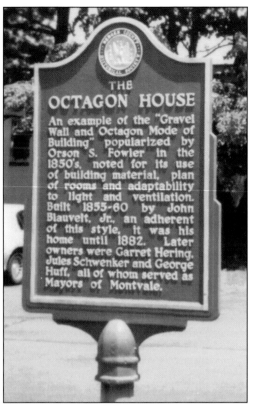

This Bergen County historical marker describes the historic significance of the Octagon House, which adheres closely to plans set forth by Orson S. Fowler in 1848 and popularized in the 1850s. It is one of only two existing octagon houses in Bergen County.

One of the oldest known pictures of the Octagon House is from a postcard mailed in 1907. The building was constructed around 1855–1860 by John Blauvelt Jr., who had a mill on the nearby Pascack Brook. After his death, his daughter Jane Amelia and her husband, Garret F. Hering, lived in the house. There are no shutters on the building, and three of the four chimney pots are visible.

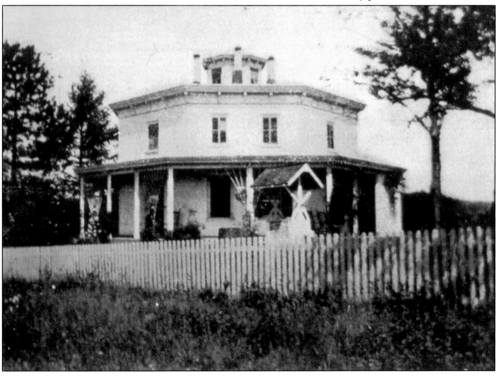

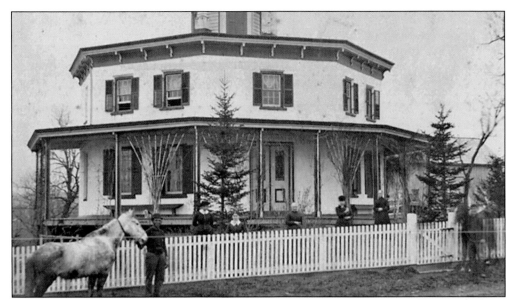

This picture, taken a few years later, shows that shutters have been added. The people in the photograph are unidentified but are likely members of the Garret F. Hering family who lived there at the time. Apparently, no one told the man on the right and his horse not to move while their picture was being taken. (Courtesy of Joe Lombardi.)

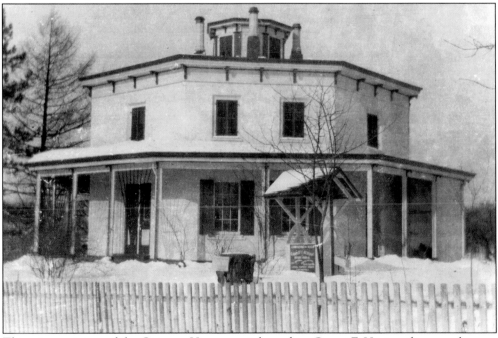

This winter picture of the Octagon House was taken when Garret F. Hering, the second mayor of Montvale, was living there. The sign reads, "Commissioner of Deeds / Garret F. Herring / Notary Public / Fire Insurance / Conveyances / Title Research / Legal Papers Drawn / Typewriting." Apparently, he offered everything one would need to buy or sell property. The sign on the tub probably advertised his cider. Notice that the upstairs shutters are closed, no doubt to keep in the heat. (Courtesy of PHS.)

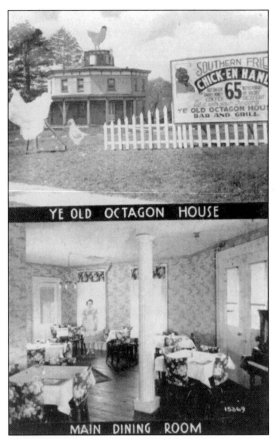

YE OLD OCTAGON HOUSE

MAIN DINING ROOM

Over the years, the Octagon House has been used not only as a residence, but also as a guest lodge for summer visitors, an office for a notary and commissioner of deeds, various restaurants, an insurance agency, a dog groomer, a beauty salon, and a florist. This 1930s postcard features the chicken on top of the house advertising a 65¢ chicken dinner—quite a bargain, even during the Depression. In the 1950s, George and Agnes Huff bought back the home he had been raised in, and again, it became a restaurant.

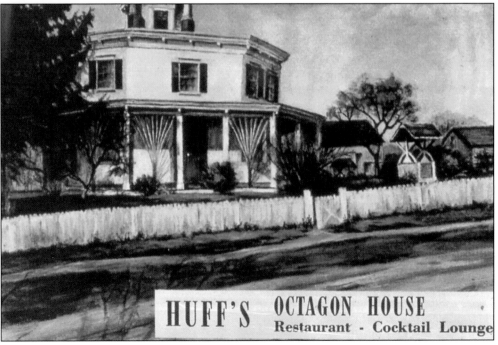

HUFF'S OCTAGON HOUSE
Restaurant - Cocktail Lounge

20

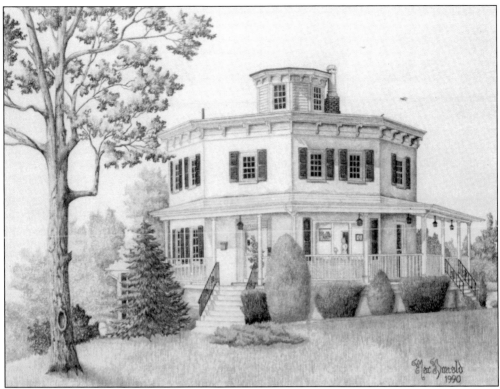

In 1976, Montvale artist Carolyn MacDonald drew several sketches of Montvale at the turn of the 20th century, including the train station, schoolhouse, and Octagon House. In 1990, she drew this sketch of what the Octagon House looked like then, and the sketch was made into prints and notecards. In 2003, with the opening of the new municipal complex, MacDonald was asked to design a new borough logo, which she very graciously agreed to. Using vintage postcards, she added the additional chimney pots to the roof and designed the beautiful logo familiar to all residents.

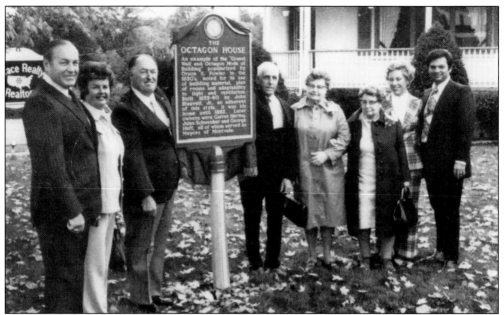

On October 13, 1974, the Bergen County historic marker for the Octagon House was dedicated. In attendance were, from left to right, Mayor Willis Swales, Agnes Huff and former mayor George Huff (previous owners of the Octagon House), Roy Blauvelt (whose family once owned the house and in which he was born), his sisters Helen and Amy Blauvelt, and Louis and Don Terrace (then-owners of the Octagon House and Terrace Realty).

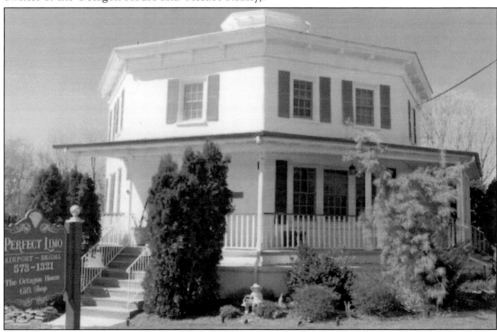

Over the last 150 years, the Octagon House has had many owners. Since 2005, the house, which had been previously landmarked by the Borough of Montvale, has been owned by Doris and John Sutich and used for their Perfect Limo Service business. They made many expert repairs on the building, and in 2006 were awarded a Bergen County Historic Preservation Commendation.

Two

Montvale and Upper Montvale

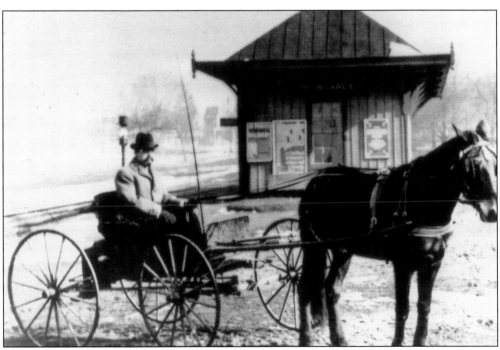

The coming of the railroad in 1871 changed not only the name of the town, known previously as Upper Pascack and Chestnut Ridge, but relocated the center of town as well. The intersection of Main Street (now Spring Valley Road) and Summit Avenue, which had previously been the center of town, became known as Upper Mont Vale (or Montvale) and the area to the east as Montvale. This photograph is of the station built several years later.

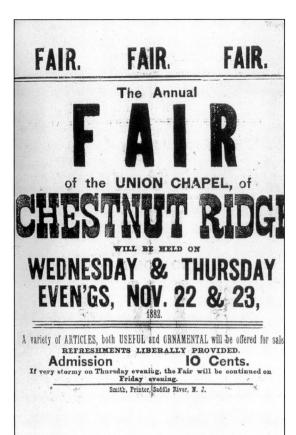

FAIR. FAIR. FAIR.

The Annual

FAIR

of the UNION CHAPEL, of

CHESTNUT RIDGE

WILL BE HELD ON

WEDNESDAY & THURSDAY
EVEN'GS, NOV. 22 & 23,
1882.

A variety of ARTICLES, both USEFUL and ORNAMENTAL will be offered for sale

REFRESHMENTS LIBERALLY PROVIDED.

Admission IO Cents.

If very stormy on Thursday evening, the Fair will be continued on
Friday evening.

Smith, Printer, Saddle River, N. J.

This 1882 poster was for the Union Chapel or Sunday school, located on the west side of Chestnut Ridge Road, across from the present-day Dairy Queen. The area known as Chestnut Ridge was on both sides of the present-day Chestnut Ridge Road and extended north into New York State.

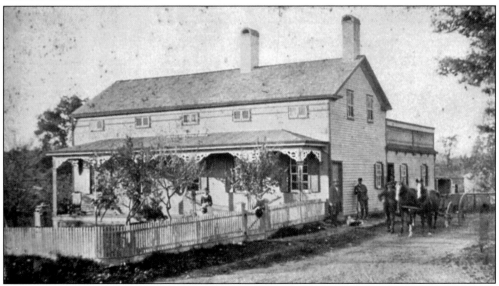

This is a picture of the home of Minnie and James "J.D." Van Riper, taken about 1879. It was located on the northwest corner of Main Street (now Spring Valley Road) and Summit Avenue. At one point, it served as a stagecoach stop; the stage would proceed to Closter, where passengers could board a ferry to New York City. J.D. stands by the door with a dog, and Minnie is at the gate.

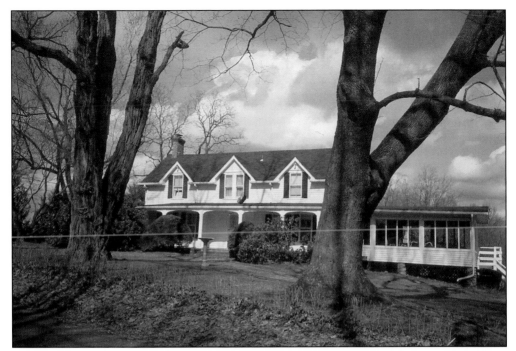

This farmhouse at 33 North Avenue is known as the J. Duryea House, as Duryea was shown as the owner on an 1840 map. According to historian Howard Durie, the original house burned down, and this house is believed to have been built on the original foundation, constructed in the mid- to late 1800s. The veranda to the right is a late-19th- or early-20th-century addition.

This house, though hardly recognizable, is still located at 76 Magnolia Avenue on the eastern bank of the Pascack Brook and is known as the Mabie Homestead. Across the road, the Pascack Brook was dammed up, and there is evidence that a sawmill operated there at one point. This house may have been the miller's home.

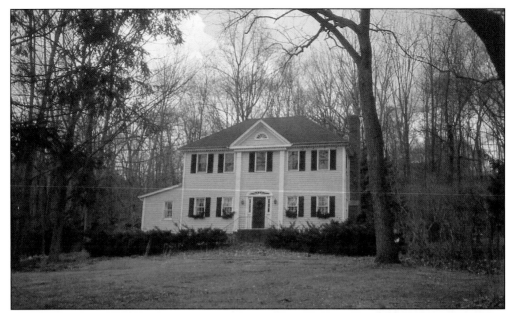

The area surrounding the Magnolia Avenue and Woodland Road intersection was known as Forshee Town, as a number of homes were owned by people of that name. This house, known as the Barrie-Lotter House, was likely built between 1856 and 1858. It had many owners, but the Barrie family owned the house from 1888 to 1945. In 1964, Howard Durie made a report on the house for then-owners Mr. and Mrs. Alfred Lotter.

These two buildings were also in the Forshee Town area. The front building at 36 Woodland Road was the original house, and the building to the north at 38 Woodland Road was the carriage house, which was converted into a private dwelling many years ago. The house is shown as belonging to Wm. Forshea on the 1876 Walker map and as belonging to Halleth on a 1912 map. The house is No. 226 in the Bergen County Stone House Survey.

Another section of town was known as Middletown, running from River Vale through Montvale and into Pearl River, New York, on both sides of Middletown Road. This house at 8 North Middletown Road at the southwest corner of East Grand Avenue is known as the J. Flood House. The earliest part was likely built before 1840. According to maps, it was owned by J. Flood in 1861, Mrs. E. Flood in 1876, and E.R. Teller in 1902 and 1913.

Another house in this area is 24 North Middletown Road, known as the Jacobus D. Blauvelt House, at the north corner of Cameron Court. The main house was likely built in the early 19th century. The house has the added-on appearance of a home used by several generations. Notice the four chimneys: the one on the left side of the house is a recent addition. (Photograph by Howard Durie.)

YOUR PETITIONERS therefore pray Your Honor that you call a special election to be held at some convenient place within said proposed Borough according to the provisions of said Act to the end that the legal voters within the said territorial limits may vote for or against the formation of the said proposed Borough.

Dated August 11th A. D. 1894.

PETITIONERS.

This petition was signed on August 11, 1894, by 25 men and six women. The petition had to be signed by at least 10 percent of the property owner, so even though the women could not vote in the election, they could sign the petition. Eighteen of the petitioners were from old Bergen-Rockland "Dutch" families whose ancestors had immigrated over 200 years earlier. Typically, many were related to each other by blood or marriage. The other 13 were a more diverse group; nine were foreign-born, and three were married to someone foreign-born. Nineteen days later, 49 votes were cast in favor of the incorporation of the Borough of Montvale, with no opposing votes.

In 1894, Gerrit F. Hering was 57 and the operator of the sawmill and cider mill at Hering's Pond. At the first borough elections, Hering was selected as a Bergen County freeholder. He would later be elected as the borough's second mayor, serving from 1898 to 1901. He lived in the Octagon House, built by his father-in-law John J. Blauvelt. In 1900, his occupation was "cider manufacturer and saw mill." His sawmill is seen below in an 1899 photograph. The pond formed by the mill dam was known as Hering's Pond (later Huff's Pond). His son— and later, the Huffs—conducted an ice-making operation on the site. In later life, Hering took on the less-strenuous jobs of postmaster, railroad agent, and notary (see pages 19 and 43). (Both, courtesy of PHS.)

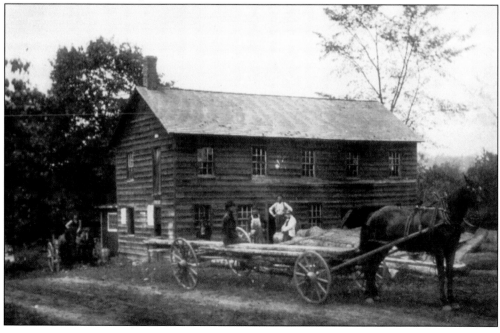

In 1894, Jacob Ter Kuile was a 41-year-old farmer and steamship agent. He was born in Holland and immigrated in 1872. He was a good choice for Montvale's first mayor, as he could relate to the immigrant residents as well as the Jersey Dutch families, in addition to being the wealthiest man in town. He and his wife donated part of their property for the first St. Paul's Episcopal Church. He died in 1910.

Jacob Ter Kuile's wife, Cora B. (Marvin) Ter Kuile, was born in New York in 1894. At the age of 35, she was widowed with eight children; the youngest were six-year-old twins. She went on to serve on the Montvale Board of Education, organize the American Red Cross in Bergen County, and help found Bergen Pines County Hospital. She died in Florida in 1955 at the age of 85. (Courtesy of Robbie Ter Kuile.)

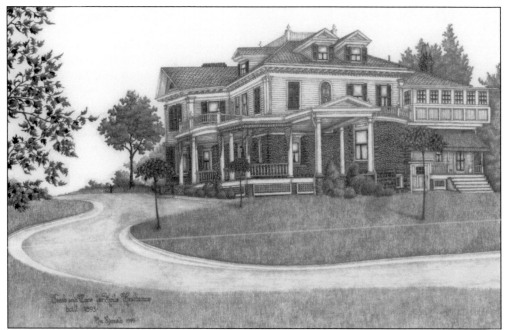

In 1999, local artist Carolyn MacDonald was commissioned by Chris Ter Kuile to draw a sketch of the house located at 79 Grand Avenue in Montvale. Working with faded photographs and the actual structure, she drew this remarkable picture. Prints and notecards were made from the original. The main house was sold in 1928 and was used as a guesthouse and nursing home for many years. The house was demolished in April 2019. (Courtesy of Carolyn MacDonald.)

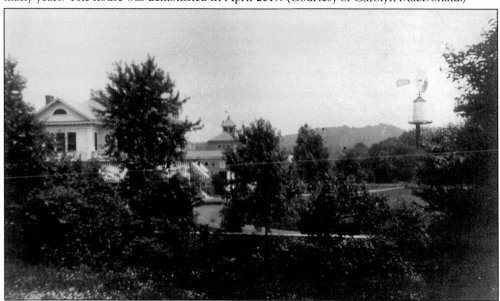

This photograph shows part of the Ter Kuile estate, which included a windmill, water storage tank, large home (seven bedrooms plus two for maids), and a barn. The large barn had stalls for four horses, stanchions for 17 cows, a carriage room, hay and feed storage, man's quarters, heated garage for three cars, and a 300-gallon gasoline storage tank. There was also a pig house, large granary, stone silo, and a modern two-story chickenhouse for 200 chickens. (Courtesy of Robbie Ter Kuile.)

NORTHERN NEW JERSEY

AT

Montvale

BERGEN COUNTY

Country home beautifully situated on high ground, facing the East. The residence, barns, garage, lawns and buildings, are all in excellent condition and repair. The entire property is free and clear of encumbrances.

Seven minutes walk from R. R. station. N. J. & N. Y. R. R. 50 minutes to New York.

Forty acres, or less if desired, of woodland and fine meadows in good hay; about three hundred feet of brook frontage and two and three-quarter acres of well-shaded lawns with shrubs and flowers. The land could be divided to suit buyer, if desired. The main residence could be sold separately.

Concrete tennis court. Drives with concrete curbs and gutters.

Seven hundred feet frontage on main road; four hundred feet of stone wall with corresponding piers and iron gates.

HOUSE: Stone and frame. Three porches (two enclosed for screens).
 Main Floor: Living room, reception hall with ingle, library, dining room, butler's pantry, kitchen, scullery, lavatory and toilet.
 Second Floor: Seven master's bedrooms, two baths and showers, two toilets, lavatory, running water in two bedrooms, two sleeping porches.
 Third Floor: Two maids' rooms with bath, large attic, metal storage room.
 Cellar: Furnace room with new hot water system, pipeless furnace for Spring and Fall, laundry, wine cellar, milk room.

WATER SUPPLY: Two wells—one with automatic electric pump, the other with gasoline engine pump.

ELECTRICITY: for lighting, cooking and power. Equipment includes electric range, dish washing machine, and laundry machinery.

TENANTS HOUSE: Six rooms and bath, running water, furnace.

LARGE BARN: Stalls for four horses, stanchions for seventeen cows, carriage room, large hay and feed storage, man's quarters, hot and cold water, heated garage for three cars in basement, 300 gallon gasoline storage tank with pump.

LARGE GRANARY: pig houses, stone silo, wood house and storage shed.

Modern two-story chicken house, with glass front, accommodating two hundred chickens, and long runs, water connections. Root cellar, and bee hives.

This desirable property is especially adapted for a gentleman's country home, convenient to the city. The neighborhood is excellent.

The property is so layed out as to make an ideal place for training horses. A track could be constructed at small expense.

If you want to be shown this property Telephone PARK RIDGE 60

—PRIVATE SALE ONLY—

For additional information address
C. ter KUILE, 30 West 44th Street, New York City

From this advertisement, the extent of the Ter Kuile estate can be appreciated. After selling the house in 1928, Cora Ter Kuile must have retained some of the property, perhaps the tenant house, as newspapers in 1930 and 1931 mention that she had arrived for the summer.

In 1895, the year after Montvale was incorporated, there was a state census. Unlike federal censuses, it did not ask for the exact age or occupation of residents. Still, this summary of the data collected offers an idea about who the first citizens of Montvale were. On May 29, 1894, there were 86 families living in 79 dwellings in "Mont Vale." There were 354 people, 287 native born (139 males and 148 females), 5 "colored" males and 5 colored females, 10 Irish born, 16 German born, and 31 other nationalities. Of the 354 citizens, 33 were under 5 years old, 87 were 5–20, 191 were 20–60, and 43 were over 60.

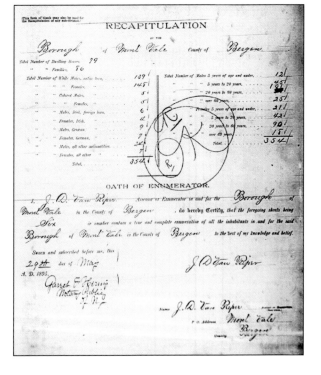

Three

EARLY HISTORY
OF THE BOROUGH

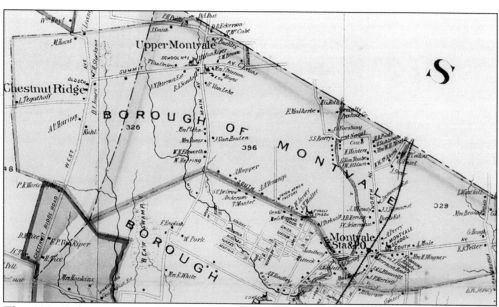

This 1902 Robinson map of Bergen County shows what Montvale looked like soon after incorporations. Just to confuse things, Grand Avenue (which runs from east to west) was called South Street, Kinderkamack was North Street, Chestnut Ridge was West Street, and Spring Valley Road was Main Street. Additional property was added in 1906 from Orvil and Washington Townships, and in 1912, the western boundary was extended to the state line with the annexation of land from Upper Saddle River. (Courtesy of Ridgewood Public Library.)

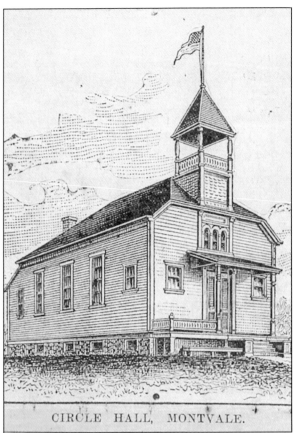

CIRCLE HALL, MONTVALE.

This sketch of Circle Hall was found in a rare copy of the January 1896 issue of the *Borough Bugle*. According to the article, the building was used for borough council meetings and social gatherings. Unfortunately, it burned down in the early 1900s.

Serrell's Mushroom Caves are barrel-vault brick structures built into the earth at the end of the cul-de-sac on Westminster Court. They were built in 1896 by Edward Paul Serrell and J. Frederik Hahn, who were doing business as the Specialty Products Company (see map on previous page). Serrell and his wife lived on the property for more than 50 years, during which he served in a variety of public offices including mayor from 1922 to 1925.

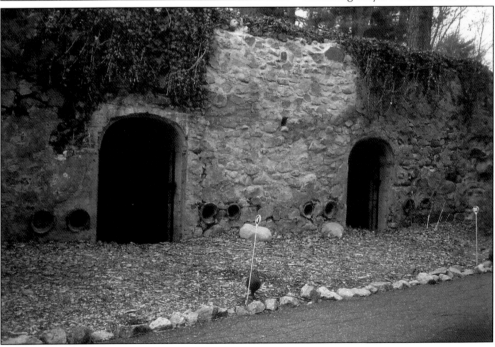

In 1896, the Montvale Borough Social and Basket Picnic was encouraging people to see the New Central School Site, which was rejected in favor of two identical schools located in the east and west (Upper Montvale) parts of the borough. Note that admission was free, but participants were warned, "No Swearing or Fighting." The program showed some interesting contests and races as well as a baseball game. The prizes for the contests show the organizers had a keen sense of humor, even though some of the contests would definitely not be on a 2019 schedule of events.

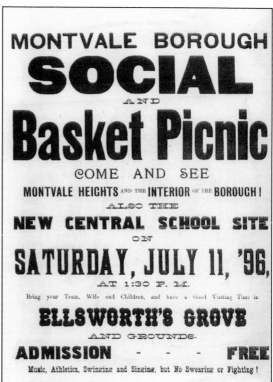

PROGRAMME.

PRIZE.

1—BOYS' PIE EATING RACE...Rhubarb Root
2—LARGEST FAMILY ON GROUNDS.............................1 Pound Candy
3—OLDEST MAN ON GROUNDS......................................Cane
4—OLDEST WOMAN ON GROUNDS..............................Box of Snuff
5—MAN WITH THE LONGEST HAIR..............................Barber's Ticket
6—GIRL WITH THE LONGEST HAIR..............................Pair of Scissors
7—HEAVIEST MAN...Anti-Fat
8—HEAVIEST WOMAN..Cushion
9—TALLEST MAN—OVER 21...Tape Line
10—TALLEST WOMAN..Step Ladder
11—HUNGRIEST LOOKING FARMER...............................Loaf of Bread
 Votes 1c. each. Money to the Winner.
12—BIGGEST BABY...Stick of Candy

Nos. 13, 14, 15, 16, 17, 18 and 19, will be decided by vote. Votes on each contest, 1c. each.

13—BIGGEST CRANK IN THE BOROUGH..........................Coffee Mill
14—BEST NATURED MAN PRESENT..............................Sour Pickle
15—MOST DIGNIFIED CITIZEN.......................................Jumping Jack
16—BEST LOOKING YOUNG MAN....................................False Moustache
17—BEST LOOKING YOUNG LADY..................................Looking Glass
18—PRETTIEST BABY..A Rattle
19—BEST DANCER—OVER 50...Pair of Slippers

Races at 3 P. M.

20—FOOT RACE—BOYS UNDER 10.................................Jack Knife
21—FOOT RACE—BOYS OVER 10....................................Pocket Book
22—SACK RACE...Bottle of Liniment
23—TUG OF WAR...Pair of Suspenders
24—BARREL RIDER...Hoop Skirt
25—JUMPING CONTEST...Suspender Buttons
26—PITCHING QUOITS..$——
 Entrance, 1c. each. Money to Winner.
27—TREE CLIMBING...Bird's Nest Pudding
28—CAKE WALK...Johnny Cake
29—ALL AROUND ATHLETE...Turn Over
30—BEAN GUESSING..Pot to the Winner
 Guesses, 1c. each.
31—SPELLING MATCH..Dictionary
32—SCHOOL SITE ELECTION.—FOR ALL RESIDENTS OF THE BOROUGH UNDER 21

Base Ball Game at 1:30. Mont Vale Team.......................Tin Cu

Committee of Awards:

John Male, Res. VanRiper, Joseph H. Ware, Alfred M
 Crotty, J. Y. Johnston, Garry VanHouten.

Grand Bouncer - - - Patrick Haye

Come from the East,
Come from the West,
Come to this spot,
And "pull down your vest,"
And we'll do the rest!

PARK RIDGE "LOCAL" PRINT.

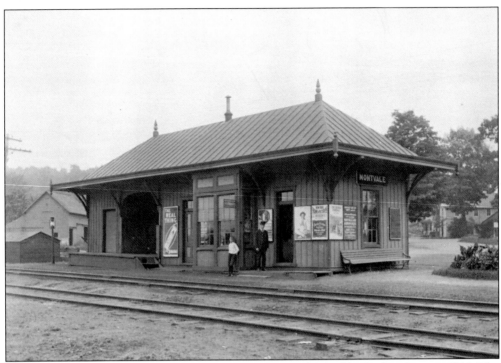

This picture is from the book *The Next Station Will Be*, published by Railroadians in 1910. The caption stated, "Poster on end of the building advertises homesites at $60.00 and-up in the farming area served by Montvale station which is about a mile short of the New York state line."

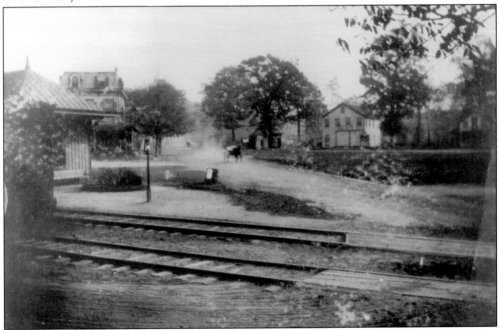

This picture was likely taken in the late 1890s or early 1900 from the railroad crossing looking east on Grand Avenue. The train station, with hitching post for horses, and Ackerman Brothers general store are on the left, and Linderman's livery can be seen in the distance on the right.

From this 1906 Ackerman Brothers advertisement, found in a rare copy of the *Borough Bugle*, a short-lived Montvale newspaper, it is known the store was founded in 1871. The Montvale store was located next to the train station on Grand Avenue. It was purchased and torn down in 1966 by the borough, and the property is now part of the northern section of the park.

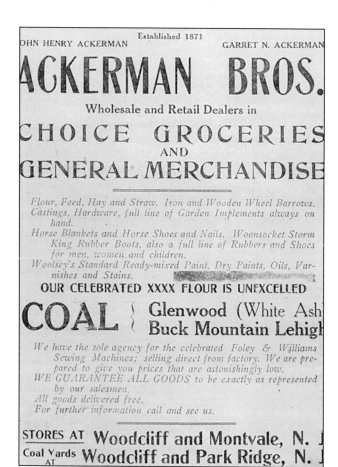

From the 1910 census and a 1912 advertisement, Paul Hilbig had taken over the Ackermans' store. This undated postcard shows the west side of the store and barn as seen from the railroad tracks. The middle of the three wagons was likely the delivery wagon. The store was later owned by the Bruns family. In the 1940s and 1950s, the penny candy sold there was very popular with the local pupils.

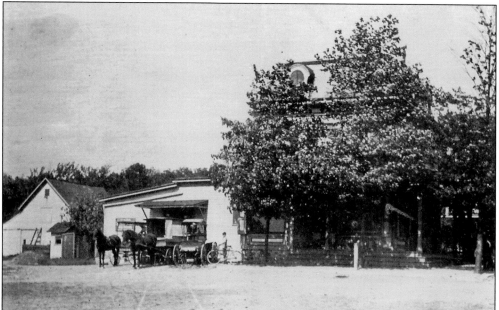

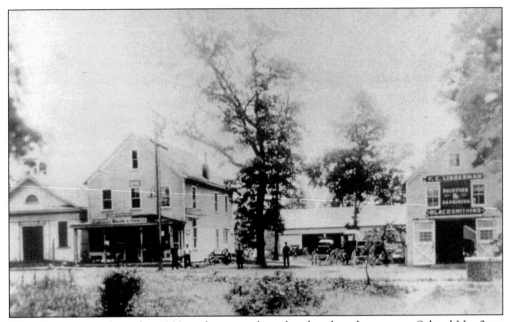

This picture was taken after 1909 as that was when the abandoned one-room School No. 2 on Grand Avenue was purchased by future mayor Fred C. Linderman. He moved it the short distance across the street to add to his blacksmith shop and carriage wagon and harness shop (which eventually became a hardware store). In later years, dances and council meetings were held in Linderman's Hall, located on the second floor of one of his buildings.

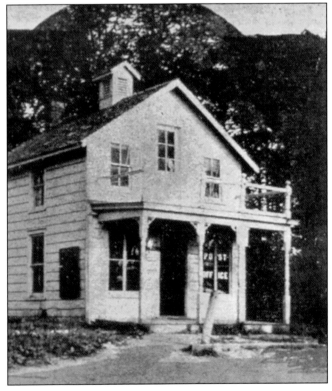

This photograph of the Montvale post office was found on an undated postcard. Later, the post office was located in several general or grocery stores. In the 1940s, it was moved to the north end of the Montvale Building and Loan Association Building on the corner of Kinderkamack Road and Franklin Avenue.

As the 1908 postcard above shows, the boardinghouse known as Climbers was aptly named. The message is from one of the hundreds of summer visitors who flocked to Montvale in the late 19th and early 20th centuries. The house has been beautifully maintained over the years and is still easily recognizable at 118 Woodland Road—just look for the stairs. The Climbers was designated a Montvale historic landmark in 2004. Taken on the porch of the Climbers (sometimes spelled "Clymbers"), the 1907 photograph below shows summer guests, likely with the host family. Although most of the summer visitors stayed in boardinghouses, some rented houses while others purchased summer homes in the borough. Many summer visitors eventually became permanent residents of Montvale. (Both, courtesy of Ronald Busse.)

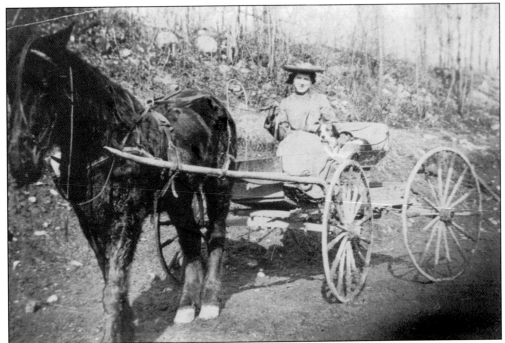

This 1906 photograph is of Daisy Antonia (Schwannecke) Busse driving her buggy. Notice her dog is with her on the seat. She and her husband, William, were married the previous December in New York City when she was 22 years old, and they moved to Montvale soon after. They were the owners of the Climbers. (Courtesy of Ronald Busse.)

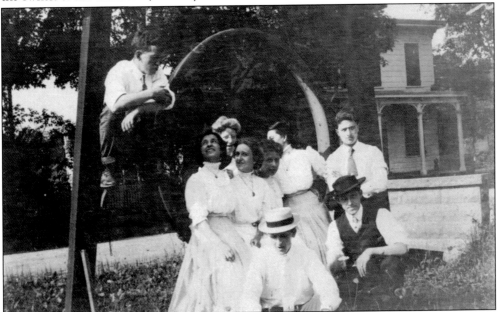

This 1907 picture shows young people around a fire gong in the park across from the Grove House. Made from discarded steam engine wheel rims, they were struck with a hammer to summon help. This fire gong was constructed many years before Montvale had an organized fire department. It is now one of the two on Memorial Drive (see page 107). (Courtesy of Ronald Busse.)

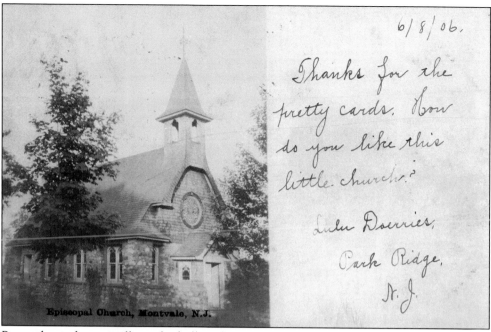

Episcopal Church, Montvale, N.J.

6/8/06.

Thanks for the pretty cards. How do you like this little church?

Lulu Doerries,
Park Ridge,
N.J.

Postcards can do an excellent job of telling the stories of why Montvale attracted so many summer visitors every year. The June 9, 1906, postcard above sent to Attleboro, Massachusetts, is one of the oldest known. Prior to March 1, 1907, postcards were printed with a space for writing on the front, though cards printed before then were often mailed up until the late 1910s. After March 1, 1907, postcards could have a divided back with both the address and message on that side (see pages 77 and 78 for more on St. Paul's). The postcard below, dated Aug 22, 1908, is from a new employee of the Grove House, the only hotel in town, located near the railroad station. The sender seemed to enjoy Montvale, "a dream of a place away in the woods."

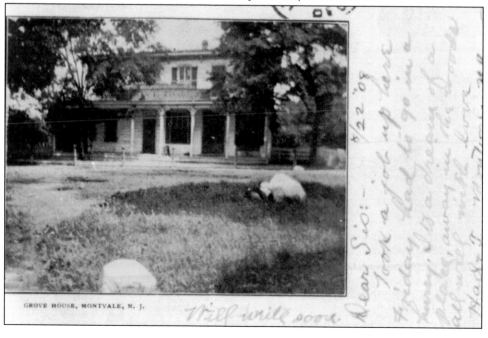

GROVE HOUSE, MONTVALE, N. J.

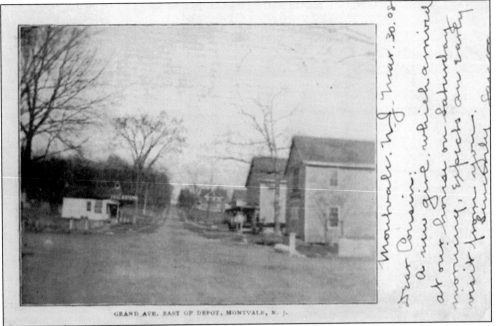

GRAND AVE. EAST OF DEPOT, MONTVALE, N. J.

Two postcards feature this view of Grand Avenue with the "Real Estate" office on the left. This one is dated March 30, 1908, and the other July 16, 1911, which reads in part, "I was to New York twice this week I saw Aunt Magie and Cousin Grace. . . . We are all going to an excursion on the hudson Aunt Magie and Grace expects to come good bye Herman." (PHS.)

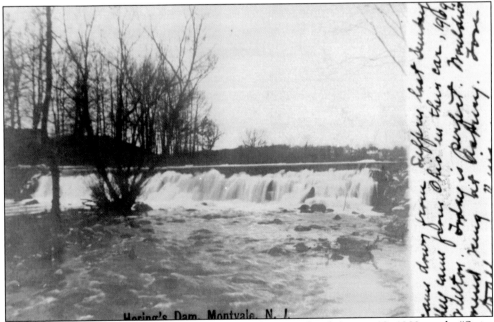

Hering's Dam, Montvale, N. J.

Another postcard with the same photograph as this one, dated August 12, 1909, reads, "Swim about this dam. A tennis court is in the making." Hering's Dam (later Huff's Dam) had been there for more than 100 years. It was used to power his sawmill and cider mill, and ice was harvested from the pond in the winter when the ice was as much as 12 inches thick.

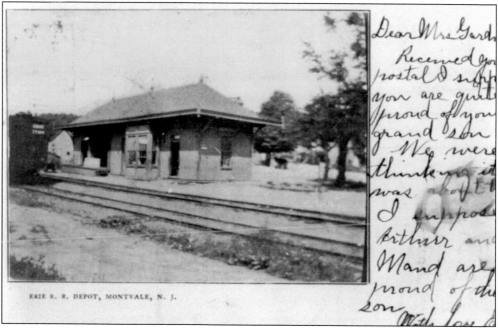

ERIE R. R. DEPOT, MONTVALE, N. J.

Sometimes, postcards were used by local people as an inexpensive means of communication. This one reads, "Dear Mrs. Gardner, Received your postal suppose you are real proud of your grandson. We were thinking it was about time. I suppose Arthur and Maud are proud of their son. With love E."

Another postcard of this building (without the workers, wagon, and cider kegs) dated July 16, 1910, reads, "This is where they make Jersey Applejack." It was mailed from Pearl River, New York, to Minna Busse, the Clymers, Bergen County, New Jersey. A 1912 advertisement had "G.F. Hering maker of Sparkling cider." Jersey Applejack was an alcoholic beverage made from fermented apples; no wonder the cider mill was so well known. (Courtesy of PHS.)

MONTVALE
New Jersey

"The most healthful district east of the Rocky Mountains."— United States Geological Survey.

The place to live for people who know how to live : : : : :

49 Minutes from the McAdoo Tunnels

POWHATAN—A rustic residential park, in the hills of New Jersey, privately owned, and managed by an Association (not real estate men or speculators) for the sole benefit of its RESIDENT members—is the most attractive spot in the East for the building of a Craftsman home. Absolutely pure water, perfect drainage, fine schools and, quite important, first-class neighbors— THESE ARE GUARANTEED YOU. No mosquitoes; no malaria.

Cease paying tribute to the iniquitous rental system—OWN a home of your own. Easily possible if you're a member of the Powhatan Colony. Write for full particulars,

Secretary, The Powhatan Association
MONTVALE, N. J.

Powhatan Park featured in an ad in The Craftsman magazine, 1910.

This early advertisement for Powhatan appeared in a 1910 *Craftsman* magazine. The houses, most of which started out as simple bungalows, were built from just before 1910 to the mid-1950s. Unlike most housing developments, each house was unique with a variety of styles. Most of the lots were 75 feet to 100 feet wide. Powhatan Park would eventually encompass more than 100 homes in the area on the west side of East Grand Avenue, which includes the present streets of Waverly Place, Forest, Westmoreland, and Hillcrest Avenues and parts of a few cross streets. Most are still standing, and some have additions. The McAdoo Tunnels mentioned in the ad was an early name for the PATH train. (Left, courtesy of Kristin Beuscher of *Pascack Press*.)

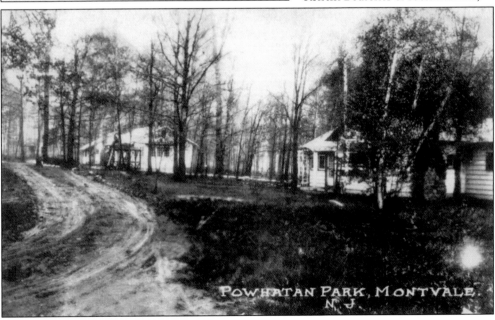

POWHATAN PARK, MONTVALE. N. J.

In 1923, a clubhouse was proposed for Powhatan Park. In order to finance it, 25¢ raffle tickets were sold for a Star sedan car. It was apparently successful, as the clubhouse was built and still stands as a private home on the west side of Waverly Place, just north of School No. 2 senior housing. The clubhouse had a ballroom on the main floor, bowling alleys, and a kind of basketball facility in the basement.

Seventeen years later, another advertisement appeared featuring houses for sale in Powhatan Park. The houses were considerably more expensive than those advertised in 1910. By now, builder Daniel Atkins was the principal developer. After the stock market crash in 1929, many of the houses were sold at a loss by the homeowners.

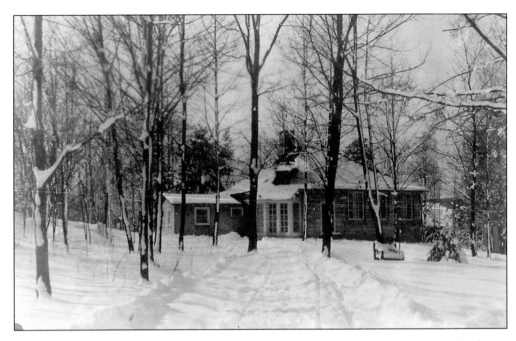

Pictured above is the back of the clubhouse after a winter storm. No two houses in Powhatan Park were alike. However, some of them feature the use of clinker bricks as decorative elements. Many had clinker brick chimneys, and others had the front facade or front entry made of clinker bricks. This house at 19 Westmoreland Avenue has all four sides of clinker bricks. Clinker bricks are created when wet clay bricks are exposed to excessive heat during the firing process. They have a blackened appearance and are often misshapen or split and laid in an irregular manner. They are named for the metallic sound they make when struck together.

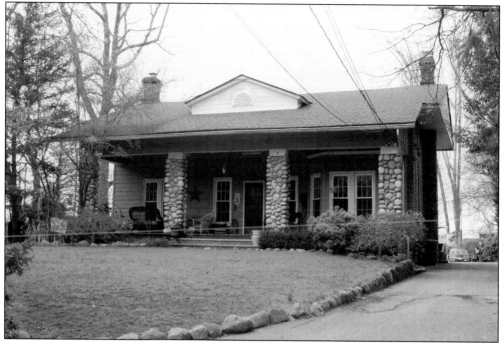

One of the more interesting houses in Montvale is at 52 Akers Avenue. The house is a Sears kit house, which were first sold in 1908. Built for Mr. and Mrs. Edmund F. Hallet in 1911, over a hundred years later, the house looks very much like the model in the 1914 Sears catalog. The parts for "Modern Home No. 124" would have arrived in a railroad boxcar and been assembled by local craftsmen. Edmund's second wife, Mae Hallet, later lived in the house; she was the well-known principal of Park Ridge High School, attended by all Montvale students at the time. This page from the 1914 Sears-Roebuck catalog mentions the house in Montvale.

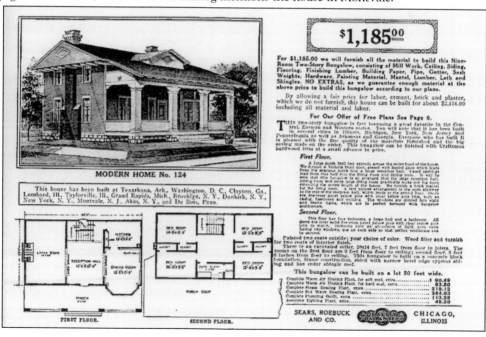

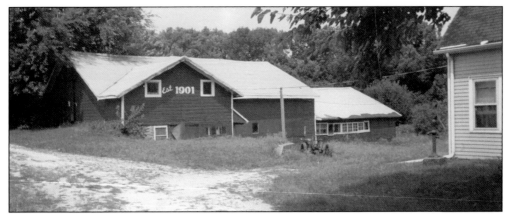

For many years, this bright red barn on Grand Avenue near Akers Avenue proclaimed that the Van Der Wall farm was established in 1901. The family sold the property to the Montvale Evangelical Church in 1961 but lived in the farmhouse for the rest of their lives. In 1900, there were 33 farms in Montvale, and by 1930, there were only 16; the last large farm, De Piero's, was closed in 2015.

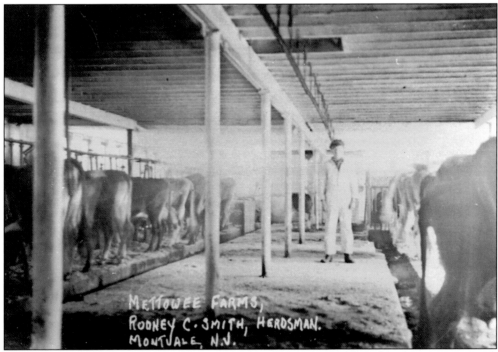

There were many different kinds of farms in Montvale; most raised fruit, but there were general, poultry, and dairy farms as well. This postcard shows the Mettowee Farm's cows and herdsman. In 1927, Mettowee Farms Dairy, A.T. Bowen, proprietor, distributed a calendar that stated, "All bottles of milk look alike—so do mushrooms and toadstools. Cheap milk is dangerous—we serve the best."

Four

AROUND TOWN

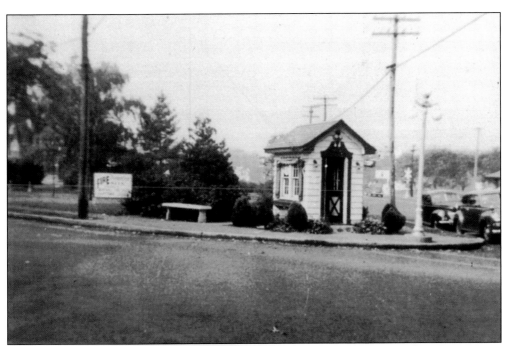

In 1913, property on Grand Avenue was purchased from Garret N. Ackerman for $2,000 for a public park, payable over 10 years at five percent interest. Several existing buildings were demolished. The police booth on the southwest corner of the park was built in 1931 using funds raised by the citizens of the town. From the automobiles seen in this photograph, the image was probably captured in the mid- to late 1930s.

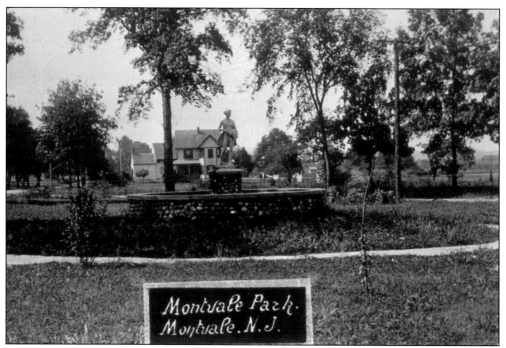

Montvale Park.
Montvale. N.J.

"The Lady," or "the Statue," shown in the 1956 postcard above, was a mystery—who was she and when or why was she put there? It is likely Ceres, the Roman goddess of grain, as she holds a cornucopia, and is also depicted on the New Jersey flag and seal. Almost every year on Halloween, tricksters threw red or blue paint on the statue and thereafter she received a fresh coat of silver or gold paint. In 1960, funds were raised by the ladies of ACTION (American Council To Improve Our Neighborhoods) for the materials to build a marble fountain in the center of town. The fountain was erected by the town employees with help from Mayor Edward Ihnen's swimming pool company. The fountain was in poor condition, so the borough decided to demolish it in 2000.

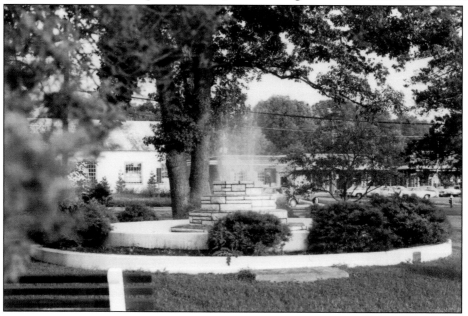

This undated (but produced shortly after 1917) postcard looking south on Magnolia Avenue (now Kinderkamack Road) contains this message: "This is the road that we take when we walk to P R where we do most of our little shopping. On the right Montvale now has a very pretty little park well kept. The distance into Park Ridge is one mile. The two stores shown are a shoe store and a confectionary store at present."

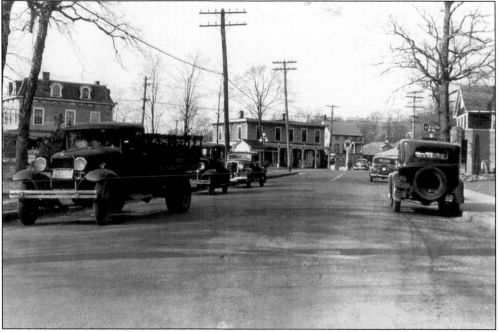

This photograph, taken in the late 1930s or early 1940s, looking north on Magnolia Avenue (Kinderkamack Road), shows a 1935 Ford truck. There is now a liquor store in town, so this image was captured after December 5, 1933, when Prohibition was repealed. In the park is the police booth with a streetlight, and on the left on Grand Avenue are the general store and hotel.

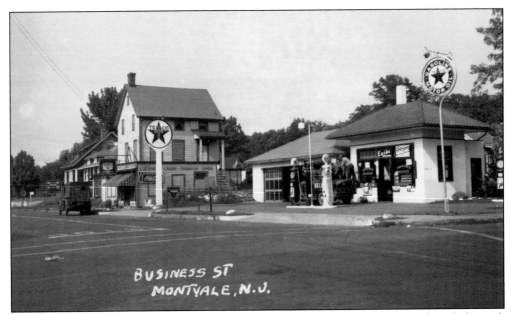

This undated postcard shows the northeast corner of what is now Grand Avenue and Kinderkamack Road looking north. Notice the Texaco station has a light by the pumps. Next door is the stationery, candy, and tobacco store rented first by the Tucoulats and later from 1939 to 1942 by the Syretts. (Photograph by A. Tocoulat, courtesy of Herbert Syrett.)

This Texaco gas station (now a 7-11) stood on the northwest corner of Kinderkamack Road and Grand Avenue for many years. It is shown here in 1932 when it was called the Triangle service station, with owner Reginald T. Behrens (left) and salesman Milton Cruden. (Courtesy of Claire B. Lamb.)

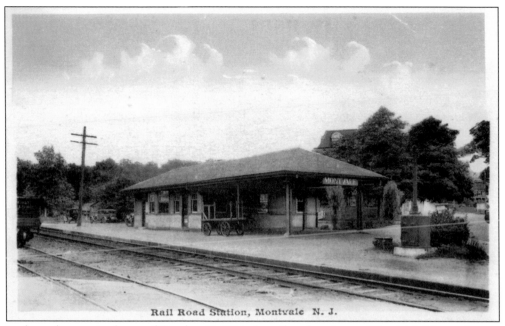

Rail Road Station, Montvale N. J.

In the early morning hours of October 11, 1921, the railroad station and Daniel Atkins real estate office both burned to the ground. Headlines in a local paper proclaimed, "Montvale Depot and Office Blown Up By Bombing Firebug." This undated postcard shows the new railroad station built several years later. From the cars at the station, this photograph was likely taken in the late 1920s.

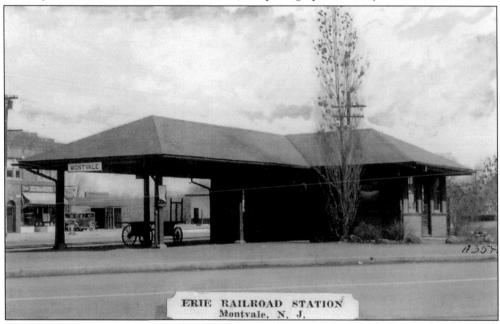

ERIE RAILROAD STATION
Montvale, N. J.

The New Jersey & New York Railroad had been taken over by the Erie Railroad before 1921. This photograph, taken in the 1930s, shows the canopy on the south side of the station. In 1954, the town began renting the station for use as a borough hall and police department. In 1961, the borough paid $1,975 to enclose the canopy and enlarge the building. The Railroad Avenue stores are in the background.

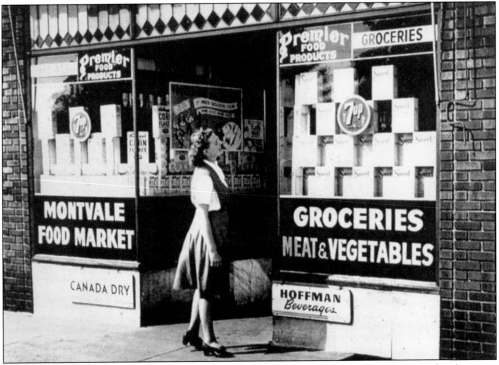

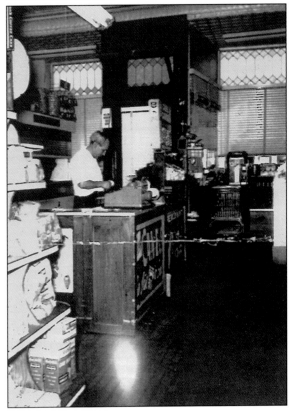

Since the early 1930s, the brick building still at 6 and 8 Railroad Avenue has been occupied by four stores. An early advertisement for Martin H. Bomm's Meat Market (phone Park Ridge 324) showed the building was then also occupied by the Great Atlantic and Pacific Tea Company, and the Montvale Pharmacy. Seen here in the 1940s, Dora Kuehkle admires the products on sale in Montvale Food Market, where she worked. Since the 1950s, Montvale Hardware has been in the building. (Courtesy of Dora Kuehkle.)

Gus Bruns is at the checkout counter in his Montvale Food Market at 6 Railroad Avenue. This was before shopping carts, when customers placed their purchases on the counter or in baskets they carried on their arms. Children loved to go shopping with their moms because Bruns always saw that they got a piece of "butcher's candy"—a slice of baloney. (Courtesy of Dora Kuehkle)

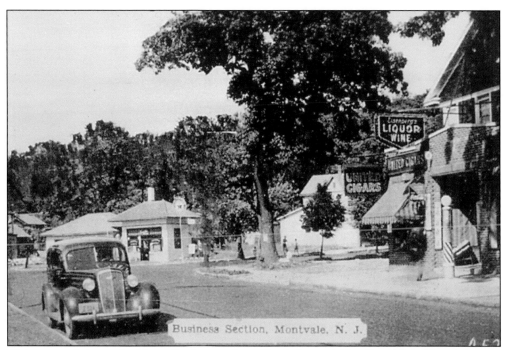

Business Section, Montvale, N. J.

This postcard shows the Magnolia Avenue (now Kinderkamack Road) and East Grand Avenue intersection. Eisenberg's United Cigar and Liquor and Wine store is on the corner. The barber pole for the shop next to Eisenberg's can be seen to the right of his store. The Texaco gas station is on the opposite corner, and there is two-way traffic on the street, which has been northbound only for over 60 years.

The Montvale Dairy Queen has been on the corner of Summit Avenue and Chestnut Ridge Road since 1950. According to guidebooks, the building is unique, as there have been no additions to it, and the original sign is still in place They still sell only ice cream—no burgers or french fries at this Dairy Queen, and no tables or chairs either. Long lines at the two service windows are expected, but the cones dipped in chocolate are a not-to-be-missed treat. (Courtesy of Ann Hopper.)

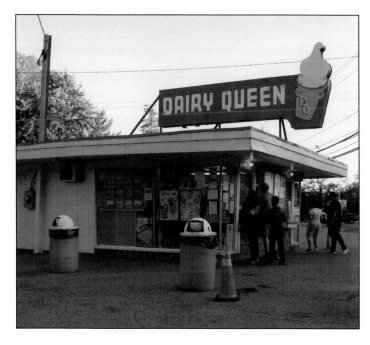

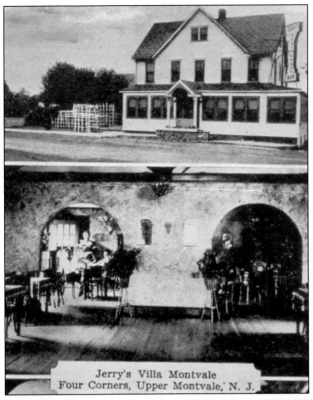

Jerry's Villa Montvale
Four Corners, Upper Montvale,' N. J.

This is a postcard of the original Jerry's Villa, a restaurant and bar located at "Four Corners, Upper Montvale," which was the southwest corner of Spring Valley Road (then Main Street) and Summit Avenue. Owned by the Della Bella family, it was the first place in the borough to serve pizza and opened in the late 1930s or early 1940s. The family lived in the old Van Riper farmhouse on the northwest corner. In the late 1950s, the farmhouse was demolished, and a much larger Jerry's Villa was built on that lot. Many weddings and formal parties were held there, including the local firemen's annual Snow Ball Dance. The restaurant was very popular for many years until it was destroyed by fire on a freezing cold night in 1983.

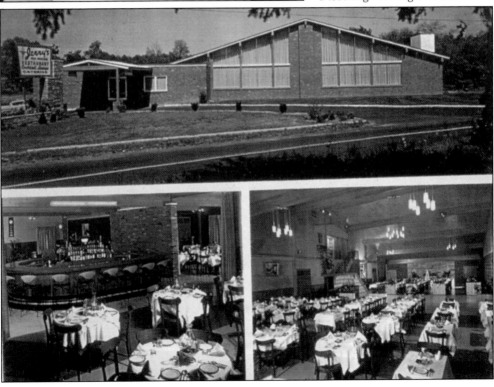

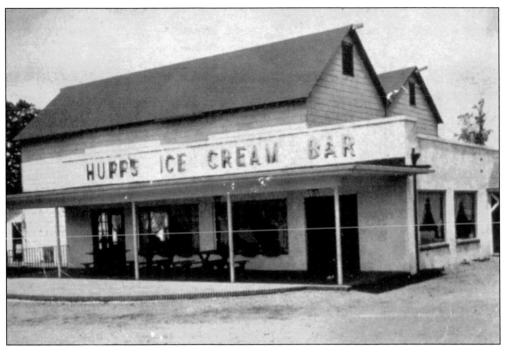

It seemed like a natural transition for George Huff, owner of Huff's Ice House, to open Huff's Ice Cream Bar in 1946. The restaurant, located next to the Octagon House at 15 West Grand Avenue, featured homemade ice cream. A separate side entrance, seen on the right of the building, was for take-out cones, shakes, and blizzards. They also served burgers and fries, and a large jukebox added to the restaurant's popularity. In later years, it became a restaurant/diner that changed owners several times. Since 2014, it has been the home of the restaurant Momma's Kitchen.

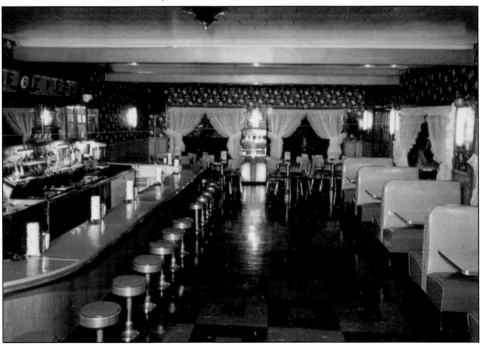

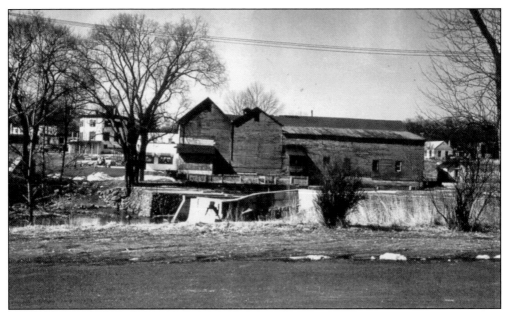

This picture was taken from the west bank of the Pascack Brook, likely in the early 1950s. The water has been let out of Huff's Pond, probably using the sluice gate, to make repairs on the dam or clean out the pond but possibly because the dam had been damaged in a storm. The large icehouse is seen to the right with Huff's Ice Cream Bar, and the Octagon House is to the left.

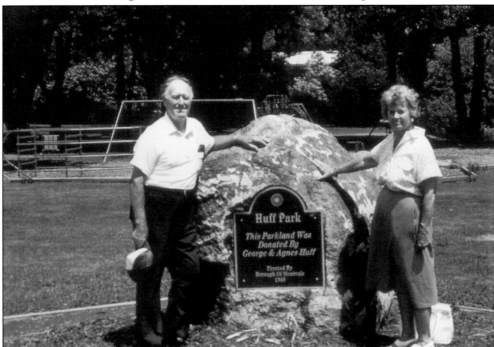

In 1991, former mayor George Huff and his wife, Agnes, had their picture taken in Huff Park next to the sign erected in 1988. The property they donated became a much-needed children's playground and picnic area on Memorial Drive. There is also a pond where fishing contests were held on Day in the Park.

According to Tom Jobson, (squatting at far left) during the Depression, the Montvale Conquerors baseball team was composed of nine members and a batboy. All were residents of a neighborhood on the east side of Kinderkamack Road north of Walnut Street. The area consisted of immigrants from Italy, Germany, and Czechoslovakia and their children. Challenged to play a New York City team, the Conquerors raised money for uniforms by raffling off a lamp. (Courtesy of Thomas W. Jobson.)

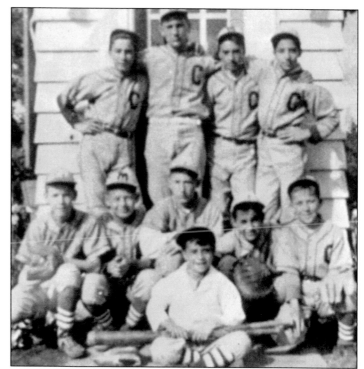

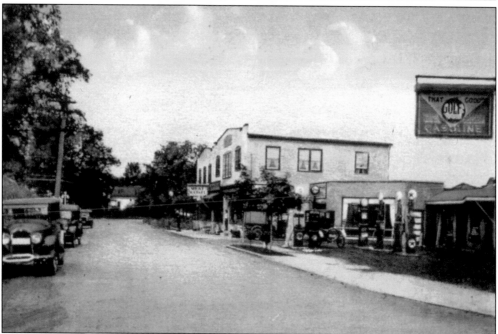

Judging from the Model T Ford at the gas station and the cars on the east side of the road, this picture of Park Avenue was taken in the early 1930s. Both the gas station and the building are still there. The meat market has been a restaurant or bar since the 1940s and has been known as Davey's Locker or Davey's Irish Pub and Restaurant since 1974. The gas station became a Gulf and, later, a Mobil station.

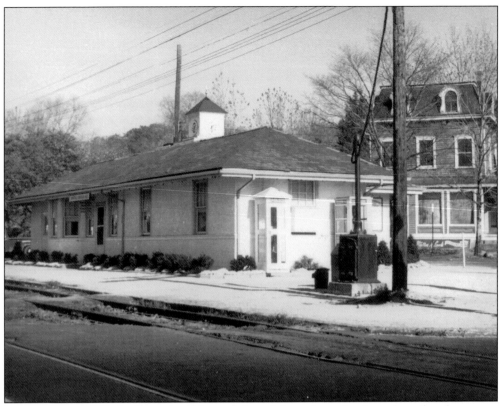

From 1954 until 1971, the Borough of Montvale leased the train station from the railroad company to use as a borough hall and police department. In 1961, the ladies of Montvale ACTION raised money for the purchase of a cupola with a clock face on all four sides. The cupola with clocks was installed in 1962.

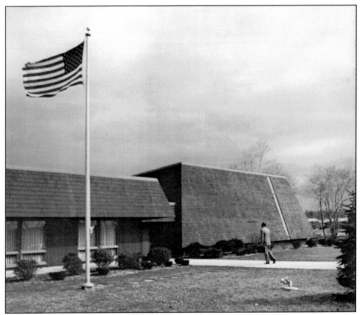

In 1971, the new borough hall and police department building on Memorial Drive was completed. It would remain the headquarters for both until 2004, when they moved to the new municipal complex (see page 91). After the building was vacated, it underwent extensive refurbishing and now serves as a senior and community center.

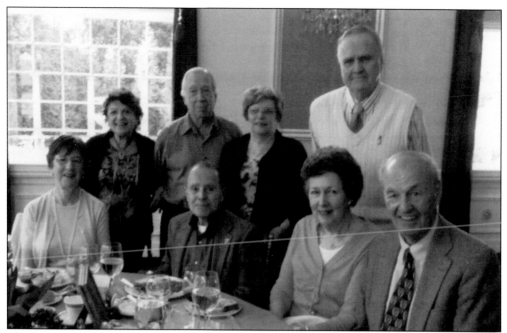

The Montvale Senior Club, established in 1960, meets twice a month at the senior center. There is a well-equipped exercise room at the center, and fitness classes are scheduled. Many groups meet regularly including a book club, canasta, mahjong, and bocce. Day trips and longer three- or four-day trips are also planned. Several times a year, as in this 2012 photograph, the seniors enjoy a luncheon at a local restaurant.

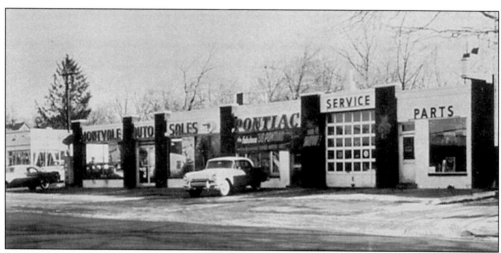

Montvale Auto Sales, a Pontiac dealership, was owned by John Tomasini. It was the only new and used car dealership in town, but it also made mechanical repairs and had an auto body shop. Tomasini was always very supportive in helping the town purchase cars for the police department.

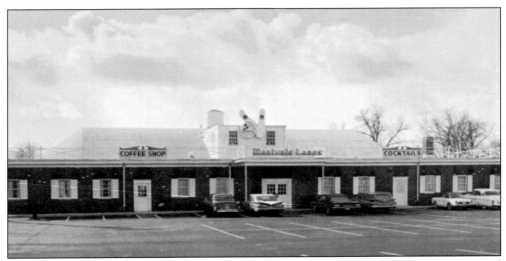

Montvale Lanes at 14 W. Grand Avenue is one of the oldest businesses in the borough. Pictured here in a 1962 Park Ridge High School yearbook photo, the bowling alley has been added onto several times since then. The bowling alley is used by the Pascack Hills High School bowling team and Montvale Recreation.

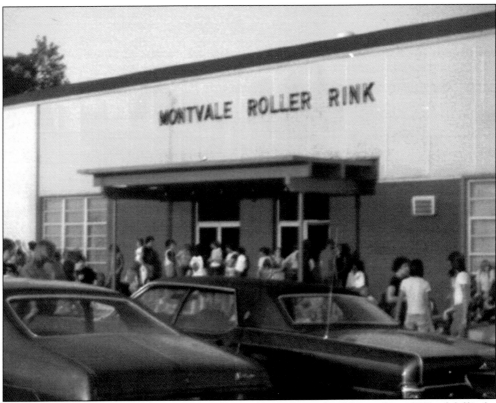

The Montvale Roller Rink, later renamed the Rink, was located in Montvale and Woodcliff Lake on Chestnut Ridge Road. The rink opened sometime in 1964 and closed on June 1, 2007. The Rink may be gone, but it is not forgotten. Fans have formed a Montvale Roller Rink Facebook page, which has more than 1,000 members. There is now a townhouse complex on the property.

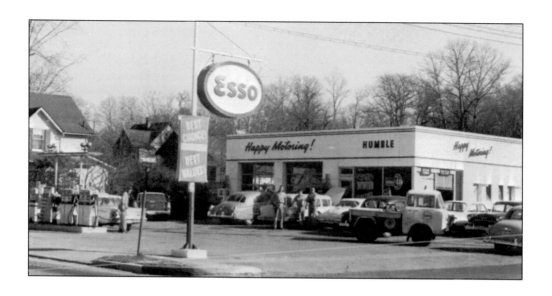

Because Montvale borders New York State, where gasoline prices are considerably higher than in New Jersey, Montvale has more than its share of gas stations. At one point, there were four in Upper Montvale and six within a mile of each other in the downtown area. Pictured here in 1961 are Dick and Tad Mandel's Esso station on Kinderkamack Road (above) and John Rothchild's Texaco station on Chestnut Ridge Road (below). Notice the price of gasoline was 26.9¢ a gallon.

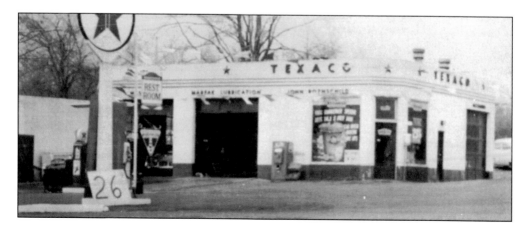

Pitman's Pony Farm was a popular place to visit, especially for children. In addition to raising ponies, owner Harold Pitman also boarded horses. He is pictured here with Mary Lou Bailiff, who worked for him exercising the horses and assisting the children around the track. (Courtesy of Mary Lou [Bailiff] Parodi.)

Many families had chickens, even if they did not live on a farm, but there were several farms that raised chickens and ducks for the New York City and Paterson markets. The largest poultry farm was Frank Etcheberry's Pearl Poultry Farm, located on what was then Pearl Street (now North Kinderkamack Road) near the Pearl River, New York, border. In addition to being a poultry breeder, Etcheberry, a native of France, had many customers for his egg delivery routes. (Courtesy of Mary Lou [Bailiff] Parodi.)

In the early and mid-20th century, there were still many farms in Montvale. At right in 1937 is Louis Bailiff on his tractor. According to his daughter, they also had chickens, goats, and a cow named Susie. For many years, De Piero's Farm was the largest farm in Montvale. Their large farm store featured not only the freshest fruits and vegetables, but also a greenhouse and bakery. Hundreds of family and school trips visited every fall to enjoy the hayrides, pumpkin picking, fresh cider, and homemade doughnuts. After 90 years, the family-owned farm and large farm store closed in November 2015 to make way for a large shopping center, the Shoppes at De Piero Farm, featuring a Wegmans and other retail stores. A scaled-down version of the farm stand, De Piero's Farm Stand and Greenhouses, is still operating at 15 Summit Avenue. (Right, courtesy of Mary Lou [Bailiff] Parodi.)

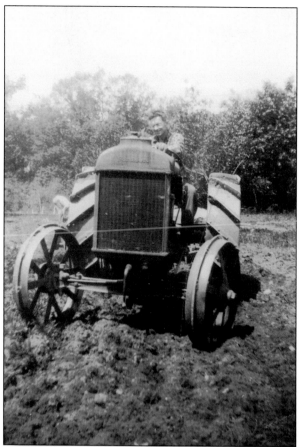

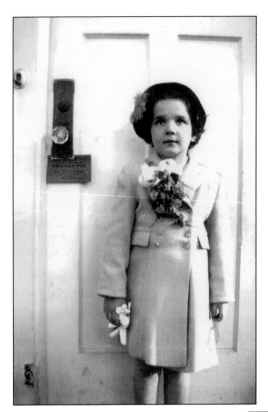

In the spring of 1946, five-year-old Maria was not too happy. She could not go to Easter services and show off her new bonnet because the Montvale Board of Health had posted an orange card on the door reading, "Quarantine Chicken Pox Do Not Enter." Her dad felt sorry for her and bought her a corsage. Upon closer look, the chicken pox is visible. (Courtesy of Maria [Pratt] Hopper.)

Charlie Gray started growing irises as a hobby. Over the years, the varieties of irises and the amount of land devoted to them grew and grew. Every spring, hundreds of flower lovers would visit his gardens and purchase his iris bulbs. (Courtesy of June Handera.)

In all seasons, the Pascack Brook was a wonderful playground for children. This 1932 photograph was owned by the late Carl Schmidt. His family owned several acres on Magnolia Avenue, with the western border being the Pascack Brook, and rented out cabins. Who were the boys? What was the boy pointing to—fish, a frog or tadpoles, or maybe a snake? It may never be known.

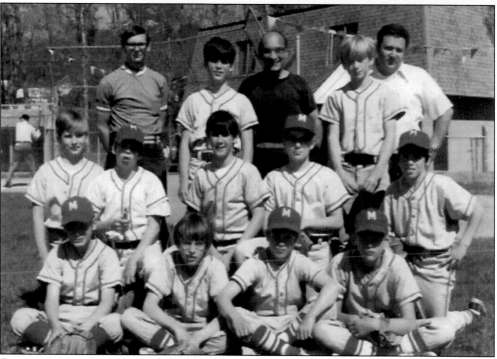

Spring in Montvale means baseball and softball. This is the 1972 Montvale Athletic League (MAL) championship team, the first picture posted to the Facebook page "Montvale, NJ Memories." Mike Furman started the page in 2011 to honor his brother Scott Furman. It is a great place to find pictures and reminisce about what makes having lived in Montvale so memorable, with over 1,400 members in 2019. Pictured from left to right are (first row) J. Fredericks, R. Onorato, M.Furman, and K. Pacifico; (second row) T. Wilhovsky, L. Cottichio, R. Sidow, T. Hamilton, and G. Miller; (third row) manager B. Hagen, B. Bucher, coach Mr. Onorato, R. Jahn, and coach S. Furman. (Courtesy of Mike Furman)

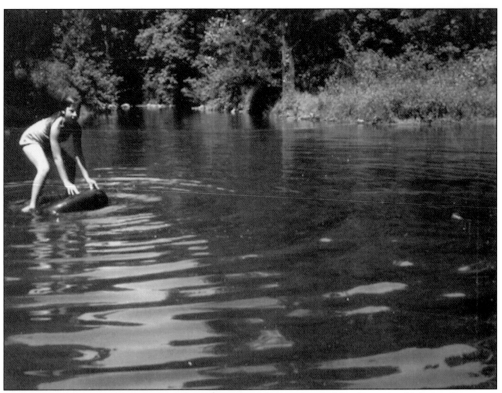

From the earliest history of Montvale, in the summer, swimming was done in the Pascack Brook. Some even paddled around in the smaller streams like the Muddy Brook, which fed into the Pascack, and the Mill Brook in Upper Montvale. They all had one thing in common: the water was very cold. Here, in 1959, Carol Holden is getting ready to dive into the pond at Magnolia Avenue. (Courtesy of Wendy [Holden] Whiteside)

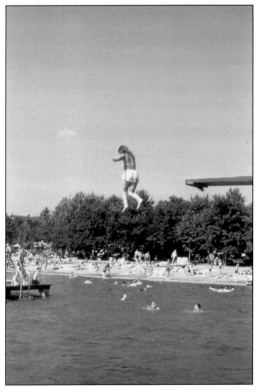

A popular place for swimming and picnicking was Murray's Laurel Lake near the southwest intersection of Spring Valley Road and Summit Avenue. Opened in the late 1940s, the large lake featured a kiddie section, a large shower pole in the middle of the lake, diving boards, and picnic tables. One of the rites of passage was to boast that one had jumped off the high dive. Here, Monica Griffith takes the plunge. The lake was demolished in the summer of 1983. (Courtesy of Ray Griffith.)

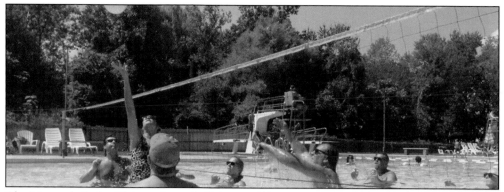

The Montvale Swim Club, at the end of Memorial Drive, opened in 1961; members posted a bond and paid a yearly fee. It closed in 2016, and the property reverted back to the borough. The swim club was used once a week by the Montvale Day Camp program. Here, members enjoy a lively game of volleyball. (Courtesy of Tom Schnaidt.)

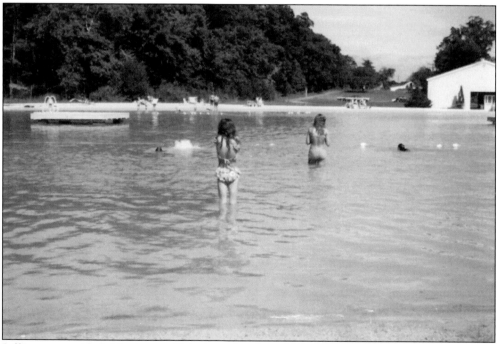

Jeff Lange provided this picture of his sisters Laurie and Chris wading at High Ridge Swim Club behind what is now 50 Chestnut Ridge Road. According to Jeff, "It was a great place to cool off in the summer. You could bring anything into the water: rafts, footballs, frisbees, etc." In the background is the entrance road, with the snack bar building on the right. High Ridge closed in the late 1970s.

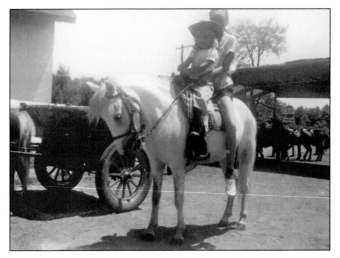

For many Montvale residents and visitors, no autumn would be complete without a visit to one of the farms in Upper Montvale for some fresh cider. After that, it was off to Pitman's Pony Farm for a ride. Mary Lou (Bailiff) Parodi, seen here helping a young cowgirl, worked at the track. The youngsters paid a quarter for three times around the track on a pony or a ride in the pony cart. (Courtesy of Mary Lou [Bailiff] Parodi.)

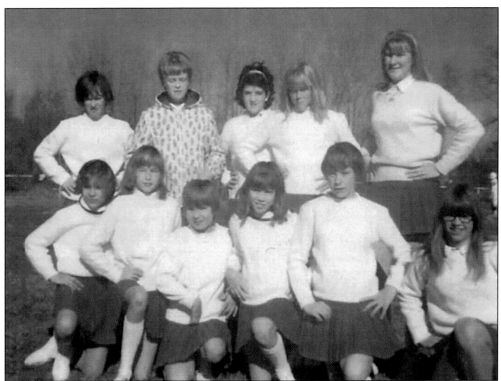

Montvale Athletic League (formerly Little League) grew from just baseball to include girls' softball, boys' and girls' soccer, football, and cheerleading. Here is a photograph of Montvale's first cheerleaders, taken in November 1976. Pictured from left to right are (first row) Libby Ciccarello, Beth Antes, Debbie Lagno, Bette Silcher, unidentified, and coach Jan Thompson; (second row) Cathy Bauer, unidentified, Jo-Anne Ballanco, Mandy Shook, and Coach Kuchar. (Courtesy Bette [Silcher] O'Conner.)

Another favorite pastime in the fall was hunting. Here, 18-year-old Bob Morgan shows off his first pheasant. The bird was shot on November 15, 1941, in the woods behind the strip mall on the east side of North Kinderkamack Road near the New York state line. (Courtesy of Herbert Syrrett.)

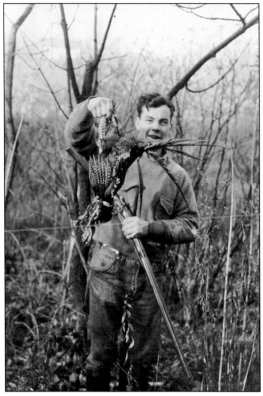

In late fall and winter months, some young men earned extra money by trapping. Here, in a picture taken November 22, 1941, when the temperature was 22 degrees Fahrenheit, Bob Morgan (left) and Joe Thomas inspect their muskrat traps. The traps were set along the Muddy Brook (a tributary of the Pascack Brook) in the woods between Kinderkamack Road at the state line and Bryan Drive. (Courtesy of Herbert Syrrett.)

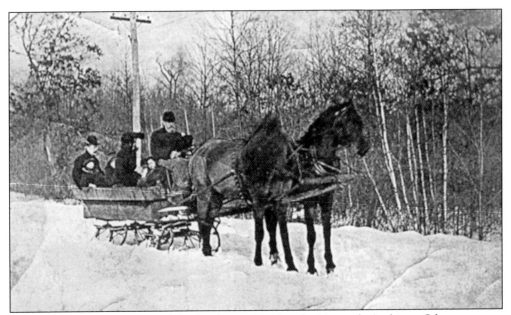

This picture of an old-fashioned sleigh ride was found in the Montvale Archives. Of course, most children used regular sleds and saucers. The most popular place for sledding was, and is, St. Paul's Hill. According to Tom Jobson, in the 1930s, they used to sleigh ride on public streets like Grand Avenue (near School No. 2), Boyd's Hill (Magnolia Avenue), and Franklin Avenue.

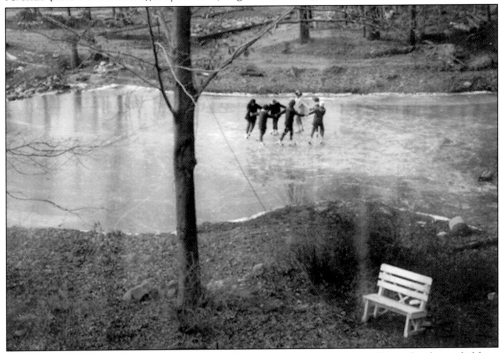

During the winter, ice skating was very popular, as there were lots of small ponds where children and adults could skate. Children would learn to skate by pushing a wooden chair in front of them. Here, a few children in 1960 skate on the Magnolia Avenue Pond. (Courtesy of Wendy [Holden] Whiteside.)

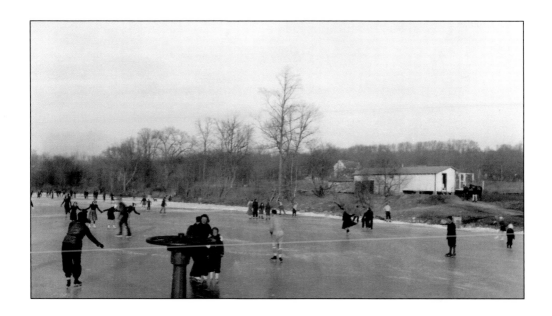

The most popular place in Montvale to ice skate was Hering, or Huff's, Pond. According to Tom Jobson, who grew up in Montvale in the 1930s and wrote in an article in the *Asbury Park Press* in 1977, "In the winter, there was skating a good three months of the year, with hockey during the day and skating during the evening, fires and hot chocolate not too far distant." There was a huge ice house next to the pond, created by a large dam, that was actually more like a small lake. Ice was harvested from the pond usually in January and stored in the icehouse. In the days when people had iceboxes, before refrigerators, an ice man would make weekly deliveries of huge blocks of ice.

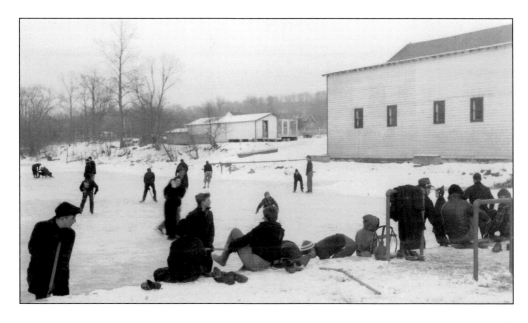

MONTVALE ZOO WILL OPEN ON APRIL 5

Fred Wohlfahrt, popular owner of the Montvale zoo, announces that he will open his place to the public on Sunday, April 5.

Among the attractions Mr. Wohlfahrt has in the zoo are two baby cub bears, only seven weeks old, for which a special cage has been built, with a cave inside of it for the bears to harbor in. There are also three monkeys, two German fitch, two mink, a fine peacock and a talking crow, besides lots of other animals. The zoo is directly opposite the Erie Railroad tracks at Montvale.

A fine up-to-date new roadstand has been built on the property, where all kinds of refreshments will be on sale.

There is plenty of parking space for automobiles. Bring the kiddies along and let them enjoy seeing the animals. There is no charge to visit the zoo.

In the late 1920s and early 1930s, Fred Wolhfahrt had a small zoo behind his restaurant on the northwest corner of what is now Grand Avenue and Kinderkamack Road. The article at left from the August 20, 1931, *Hillsdale Herald* announces the reopening of the zoo. Unfortunately, on August 14, 1931, a family of six people—a couple and their 18-month-old daughter, the wife's mother, and her pregnant sister and her three-year-old son—were all killed when the car driven by the man was struck by a train at the nearby crossing. The zoo was blamed for distracting the driver and was soon closed. All that remained of the zoo was the gazebo refreshment stand, which was sometimes rented out in later years, and a cement-lined empty fish or duck pond, seen here in a 1941 winter photograph. (Below, courtesy of Herbert Syrett.)

Five

HOUSES OF WORSHIP

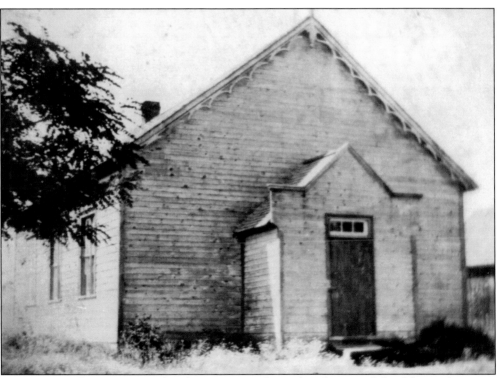

Prior to 1879, there were two churches in Montvale. Little is known of the African American church, shown on an 1876 map on Magnolia Avenue, which eventually merged or moved to the Park Ridge congregation. In 1872, an informal Sunday school group began meeting in the district schoolhouse on Chestnut Ridge Road. The chapel, seen here, was built next to the schoolhouse and became known as the Chestnut Ridge Sunday school, which was active until the early 1900s. (Courtesy of PHS.)

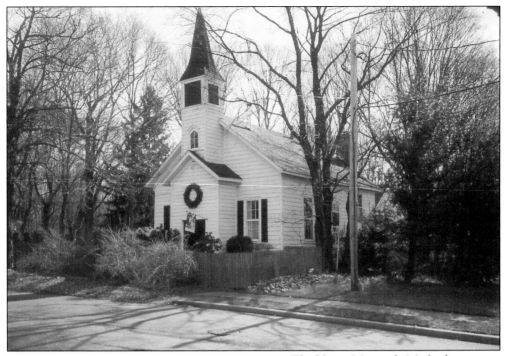

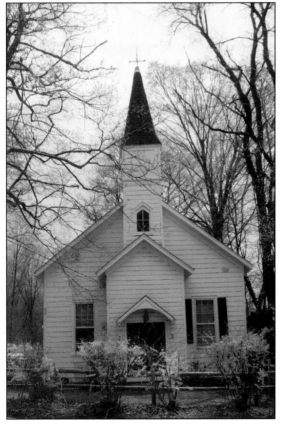

The Upper Montvale Methodist Church was originally part of the Chestnut Ridge Sunday School. The congregation broke away in 1879 and at first met in members' homes. In 1886, they built this church at 69 Summit Avenue. The church was very active for a number of years. In later years, it became an afternoon charge of the local Methodist churches and eventually merged with the Methodist church in Saddle River.

In 1973, the Upper Montvale Methodist Church was sold to Peter M. Montalbano, who converted it into a private residence while still preserving the architectural integrity of the original chapel. In 1995, the building and owners received a Bergen County Historic Preservation Award as an outstanding example of adaptive use in preserving a historic site. The then homeowner Grant Scott accepted the award.

The original St. Paul's Episcopal Church on the corner of Grand Avenue and Woodland Road, known as "the Old Stone Church," was built in 1895. It was a mission of the Episcopal Diocese of Newark. Archdeacon Jenvy described the church as a picturesque chapel that was "a marvel of cheapness." Its total cost was $1,500, with the walls made of stones taken from the adjoining fields. The horse sheds in the rear can be seen here.

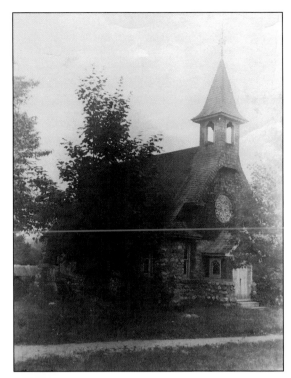

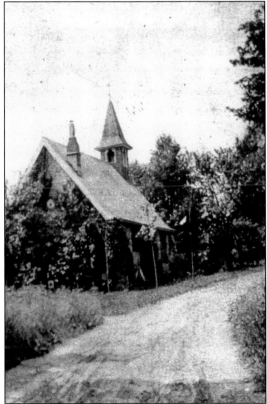

The church is seen from Woodland Road when it was a dirt road. The property for the church was donated in 1894 by Jacob and Cora Ter Kuile (see page 30). At the time, there was no Woodland Road; as the deed stated, "The property was surrounded on three sides by the Ter Kuile's property and on one side by the road (now Grand Avenue)." The deed also stipulated that there be no cemetery on the property.

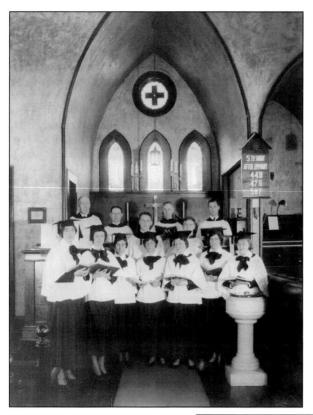

This 1933 photograph of St. Paul's Choir shows the interior of the church. In 1947, money was given for a memorial for Susan, the infant daughter of the vicar Rev. Kenneth and Ann Mackenzie. A beautiful stained glass window of Christ in her memory replaced the three windows over the altar. It and some of the other stained-glass windows and the stone font pictured here were moved to the new church in 1958.

The beautiful rosette stained-glass window was installed in 1906 by Bond Thomas, a summer resident and manager of Tiffany Studios in New York. The bell in the steeple, an unused school bell, was donated in 1935. A parish hall had been added in 1925, followed by a kitchen addition in 1949. From September 1949 until June 1953, the parish hall was rented to Montvale for use as the public school kindergarten.

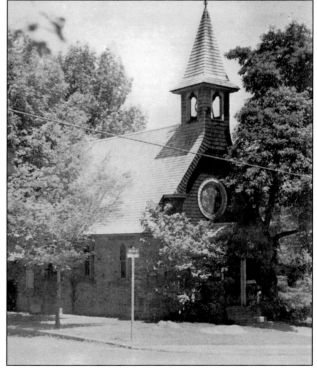

By 1957, when this photograph of the choir was taken, the congregation had outgrown the little stone church. Nine-and-a-half acres of property on top of the hill across Woodland Road was purchased from Edward Tewes for $10,000.

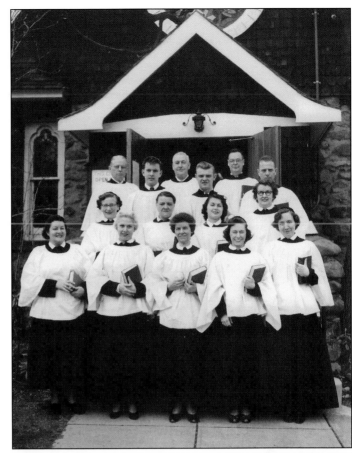

The new church on the hill was completed in 1958, and a parish hall was added in 1963. A rectory for the minister and his family was built next to the church in 1995. St. Paul's is still a growing parish. Its members include a diverse group of people from Montvale and surrounding communities. In 2020, St. Paul's Church will celebrate its 125th anniversary. (Courtesy of Dorothy Waldt.)

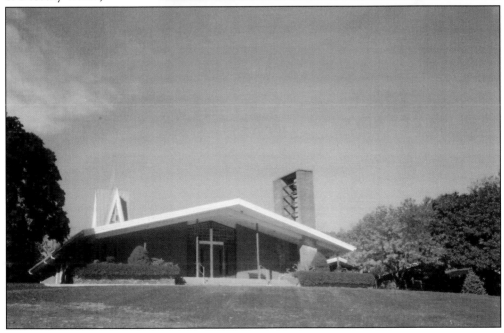

Every June, St. Paul's celebrates with a picnic held on the church grounds. Parishioners enjoy potluck salads and desserts. For the past 20 years, members of the North Jersey Regional A's, an antique car club that meets regularly in the parish hall, has served up the hamburgers and hot dogs. There are also games for young and old. This photograph is from 2003. (Courtesy of Steve McKenna.)

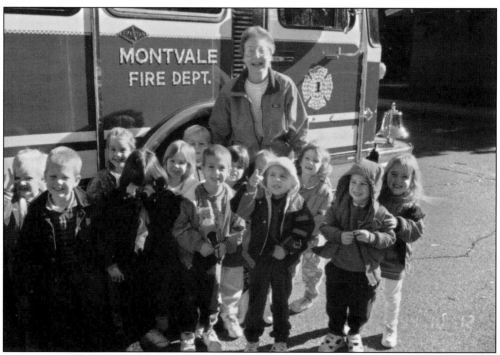

In 2019, St. Paul's Nursery School celebrated its 50th year of providing an academic and enriching learning experience for young children of all denominations. Here, in 1994, one of the classes enjoys the annual visit from the Montvale Fire Department along with Clare Costas, who was the director from its beginning in 1969 until 2008. (Courtesy of Melissa Hasse.)

From 1958 to 1963, the old church continued as St. Paul's parish hall and Sunday school. In 1965, the church and rectory were sold to a Long Island church, which founded the Church of Christ of Montvale. For a short time in the late 1980s, the old church was vacant. For the past 25 years, the International Christian Church, an Indian congregation, has been worshiping in the 124-year-old church. (Courtesy of Jesse Hopper.)

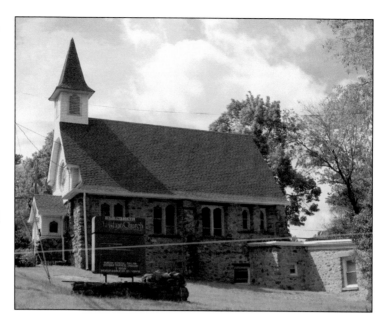

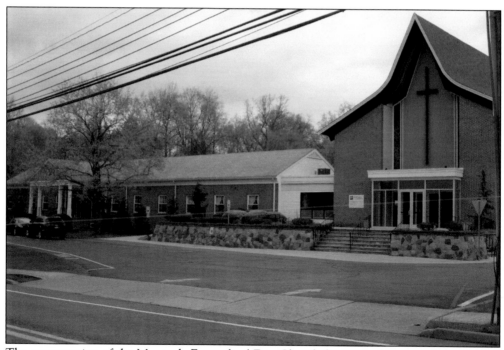

The congregation of the Montvale Evangelical Free Church first started worshipping in rented facilities in Park Ridge in 1960. In 1961, they purchased part of the farmland of dairy farmers John and Sadie Van der Wall on the corner of West Grand Avenue and Akers Avenue. In 1963, they built their original sanctuary there. In 1971, the church built a larger sanctuary with a fellowship hall below. Pictured here is the church and education building in 2019. (Courtesy of Jesse Hopper.)

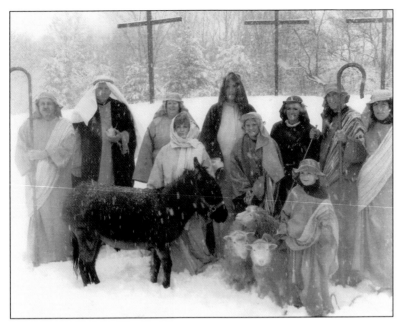

An important part of the early church's ministry was its production of the live outdoor Nativity. Live actors and farm animals were used to depict the Christmas story on the hill next to the church. It was attended by hundreds of people from the surrounding communities for several decades.

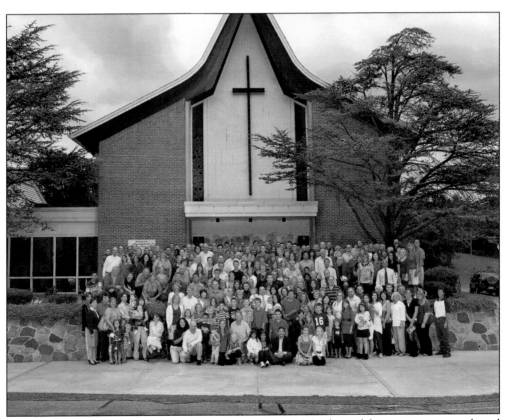

In 2010, the congregation celebrated its 50th anniversary. Members of the congregation gathered in front of the church for a group photograph.

Six

READING AND 'RITING AND 'RITHMETIC

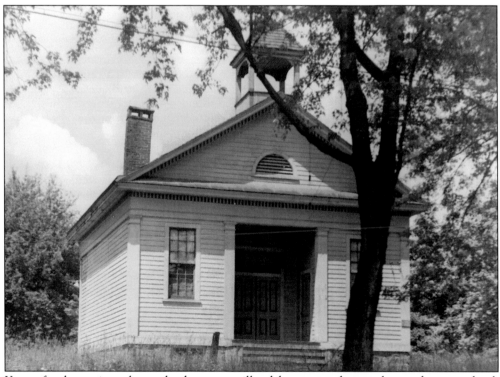

Years after becoming a borough, there was still a debate over where to locate the new school. Finally, in 1899, two identical one-room schools were built. School No. 1 in Upper Montvale, seen here, on Summit Avenue west of Spring Valley Road, was used until 1931. School No. 2 on Grand Avenue, east of what is now Kinderkamack Road, was replaced in 1908–1909 by the new brick School No. 2.

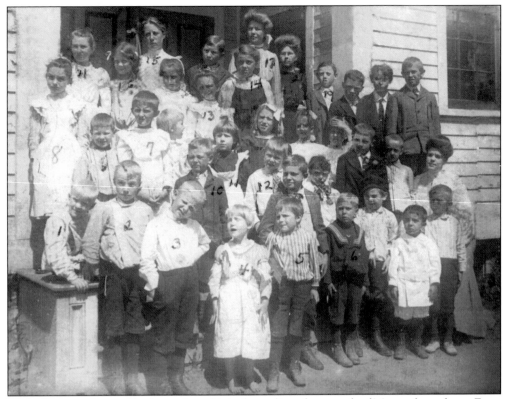

Though torn and pasted back together, this is the earliest photograph of Montvale students. From the known birthdates of some of the students, it was likely taken about 1904–1905. The entire school is shown in front of the original one-room Montvale School No. 2. Teacher Miss Bradley, top right, is seen with her students. Barefoot Maria Pratt (the author's aunt) is in the first row, apparently objecting to having her picture taken.

Ethel Stalter was the principal of Montvale School No. 2 and, later, Memorial School for 34 years. She often taught the children of her former students. She began teaching in 1913 at the age of 19 in Upper Montvale School No. 1. In 1924, she became the principal and the seventh- and eighth-grade teacher in School No. 2. After retiring in 1959, she was elected to the borough council, but in 1963 returned to the classroom, teaching fifth grade in nearby Spring Valley, New York. She retired from there at the age of 80.

By 1908, the original one-room Public School No. 2 had become too small, and a new four-room yellow-brick school was built on the same lot and also was known as Public School No. 2. Note that there is a telephone wire but no electricity to the building in this undated postcard.

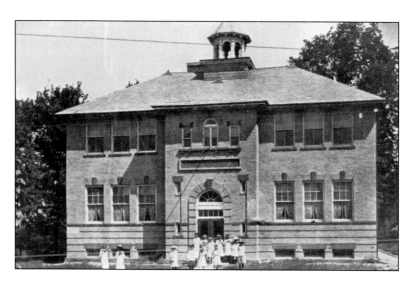

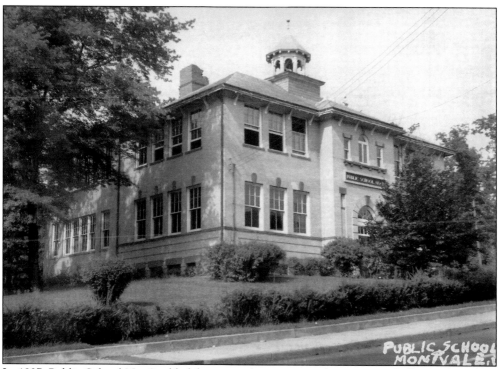

In 1927, Public School No. 2 added four new classrooms, with two on each floor. Also added were much-appreciated indoor bathrooms, an auditorium (all-purpose room) with a stage, and a principal's office. For the next 26 years, the auditorium and stage were used by the borough for many different occasions: concerts, Christmas pageants, operettas, and even council meetings. Note the electricity to the building and the broken chimney.

Looking at the eighth-grade graduation pictures decade by decade demonstrates the growth of the community. No picture of the graduating class of 1929 has been found. However, every year, Stalter's eighth-graders would present an operetta at the end of the year. In this photograph, the seventeen 1929 graduates pose in their costumes, probably from Gilbert and Sullivan's *Mikado*.

The 25 students in the eighth-grade graduating class of 1939 looked very dapper with the girls in long dresses and corsages and the boys in white trousers and blue blazers with rose boutonnieres and white pocket handkerchiefs. Their motto "Labor Omni Vincit" is Latin for "Labor Conquers All Things."

Dressed similarly to the preceding classes, the 23 students graduating in 1949 are seen here with their principal, Ethel Stalter, who is wearing a corsage. Each girl now carries a bouquet, and the boys have boutonnieres. The stage was likely decorated for the operetta, which was held the night before graduation. Their motto was, "We Gain By Our Efforts."

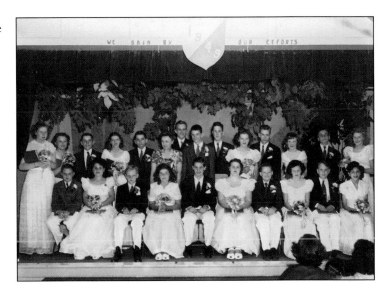

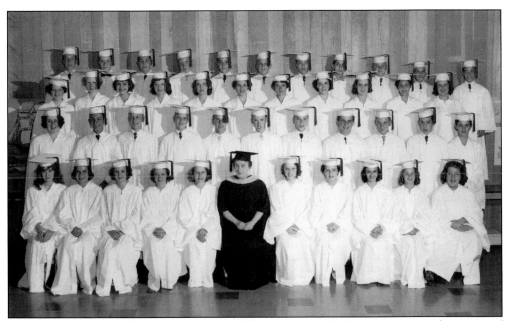

The 43 graduates in 1959 were an increase of 87 percent from 1949, demonstrating the impact of the baby boomers born after World War II. They were the fourth class to graduate from Memorial School, the first to wear caps and gowns, and Stalter's last class. By 1969, the number of graduates had more than doubled to 96. There were 114 in 1979, then 89 in 1989, followed by 90 in 1999, and 121 in 2009. In 2019, the eighth-grade enrollment was 117.

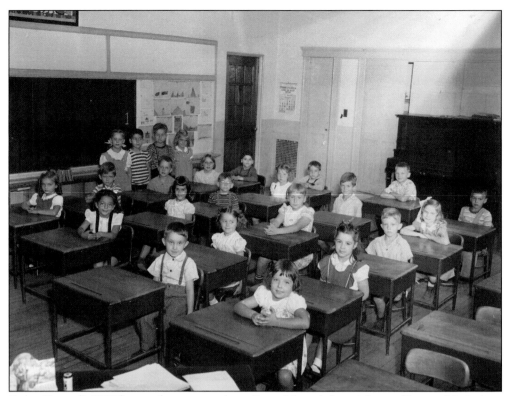

Esther Renard's 1947 first graders are seen here. Seated from left to right are (first row) Lois Ann Papay, Darwina "Vicki" Mead, Chester "C.D." Hooper, Jacqueline Smyrychynski, and Gerry Tramontozzi; (second row) unidentified, Katherine Huff, Myra Verusso, George "Skippy" Jones, and John Burkhardt; (third row) Jean Alexa, Lynn Walters, Bobby Bardell, Sally Walker, Raymond, and unidentified; (fourth row) Rosalin Fatta, Toby Overbaugh, Richard Diehl, Peggy Askew, and Caesar Meladandri; (standing, left to right) Marion Diehl, Richard Stalter, Arthur Manza, and Linda Russell. (Courtesy of Vicki Slockbower.)

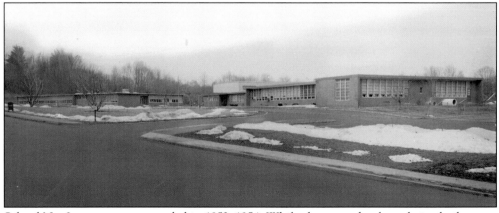

School No. 2 was very overcrowded in 1953–1954. While the new school was being built, some classes were on a split session, and the eighth grade was sent to Park Ridge. In September 1954, Memorial School on West Grand Avenue was opened. Six more rooms were added in 1958, as was an eight-room annex in 1962, pictured here. In 1983, another addition united the two buildings and added additional classrooms.

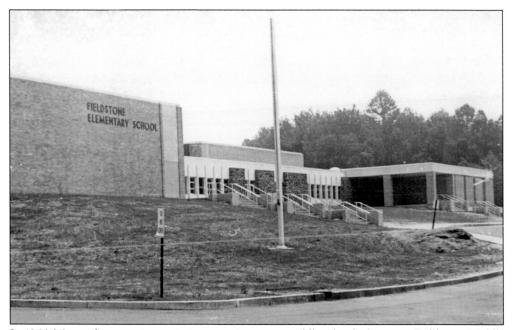

In 1966, Montvale was a pioneer in its commitment to middle school education. Fieldstone Middle School was constructed for grades five through eight. Memorial School could then accommodate all the kindergarten through fourth-grade and special needs classes, and School No. 2 was closed after 58 years.

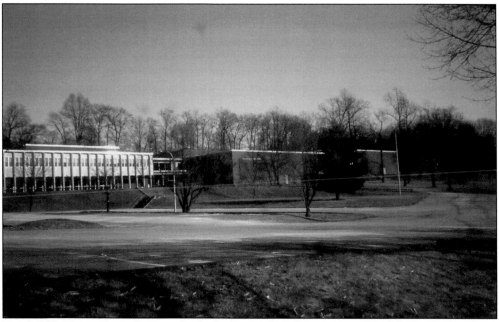

Until 1955, Montvale paid tuition for the high school students to attend Park Ridge High School. In the early 1950s, Montvale, Woodcliff Lake, Hillsdale, and River Vale joined to form the Pascack Valley Regional High School District. In 1955, the students began attending Pascack Valley High School in Hillsdale. Since 1963, they have been attending Pascack Hills High School, pictured here, on Grand Avenue and Spring Valley Road in Montvale.

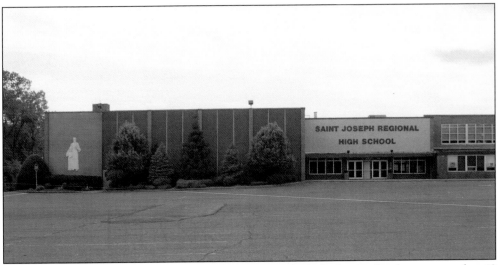

In 1962, St. Joseph's Regional High School, a 36-room Catholic boy's school, was opened at 40 Chestnut Ridge Road. Now a college preparatory high school for young men, it is affiliated with the Xaverian and Marist Brothers. The school had an enrollment of 500 students in 2019 on its 33-acre campus. (Courtesy of Jesse Hopper.)

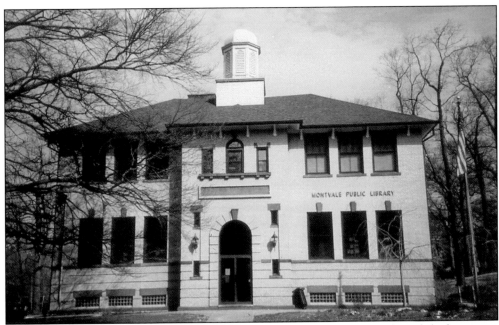

For many years, efforts had been put forth to establish a library in Montvale with little success. In 1974, the Board of Education leased School No. 2 to the borough, and the building underwent an extensive interior redesign. On October 20, 1975, the building officially became the Montvale Free Public Library. Exactly 28 years later, on October 20, 2003, the building was closed when the library moved to its new home.

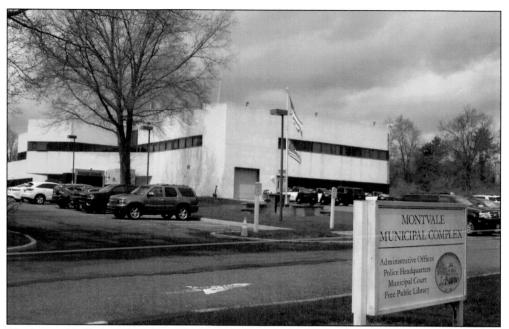

The borough offices, police department, and library were all in need of expansion for a long time. Ultimately, the solution was found by purchasing a vacant office building at 12 Mercedes Drive and converting it into the Montvale Municipal Complex. In 2003, the Montvale Free Public Library also moved to the new complex. The move was supervised by Montvale's longtime library director Susan Ruttenber.

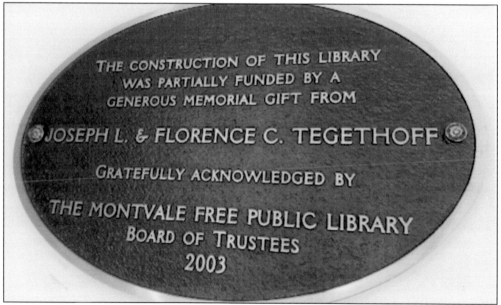

The new library more than doubled the space of the old library. The move to the new library was made possible in part by a very generous donation from Joseph L. and Florence C. Tegethoff. The Tegethoffs were longtime borough residents. When the widowed Florence passed away, she bequeathed $500,000 to the library for helping fund a new building. On July 6, 2005, a memorial reading garden was dedicated in honor of the couple.

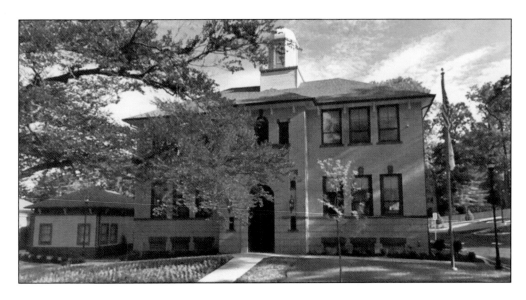

Since 2003, the Montvale Borough Council and the Montvale Historic Preservation Commission tried to preserve School No. 2, the oldest public building in the borough. Then, in 2016, Bergen County United Way, together with its partner Madeline Construction, came up with a plan to repurpose the entire building into senior affordable housing. It was dedicated on June 8, 2018, and contains eight one-bedroom rental units and two studio apartments. A new building with four housing units for developmentally disabled adults was also constructed on the same lot. The project was made possible in part by the donation of the land by the borough and a $700,000 grant by the Bergen County Freeholders. In May 2019, Montvale School No. 2 Senior Housing received a Bergen County Historic Preservation Award for best adaptive use in historic preservation.

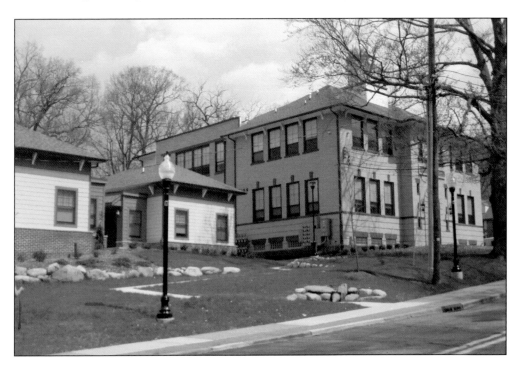

Seven

THANK YOU FOR YOUR SERVICE

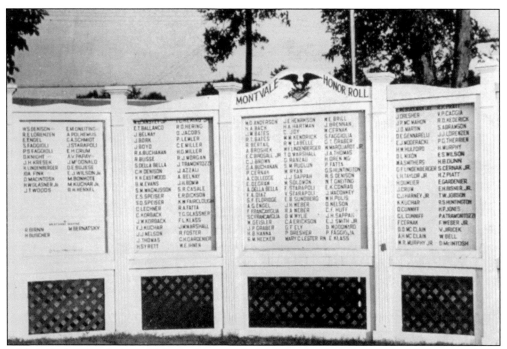

Although the population of Montvale was only 1,342 in April 1940, a total of 198 men and one woman served in World War II. A wooden honor roll erected in the south park soon needed to be expanded on either side to add names as more and more citizens entered service. The first 40 names on the center board were the first to enlist, including R.T. Bates and A. Della Bella, who both died in 1945. This photograph was taken in 1944.

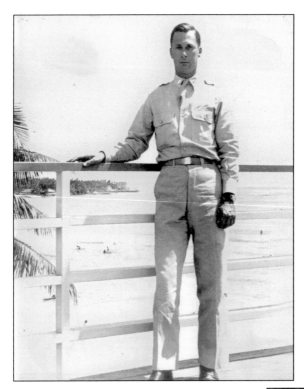

Capt. Robert Theodore Bates was born in 1912 in Chicago; he was the son of Theodore and Hazel (Smith) Bates. The family moved to Hillcrest Avenue in Montvale. He graduated from School No. 2 and Park Ridge High School. In January 1941, he enlisted in the US Army National Guard as a second lieutenant. He was activated with the 27th Division 106th Infantry and promoted to captain on January 9, 1944, after serving in a number of campaigns in the Pacific. In July 1944, he was wounded and hospitalized for two months. Given the option of serving stateside after being wounded, he chose to return to his men. On April 22, 1945, he was fatally wounded. He was survived by his wife, Lois (Behringer) Bates, his parents, and brother Capt. John W. Bates, also then serving in the Army. (Courtesy of the American Legion.)

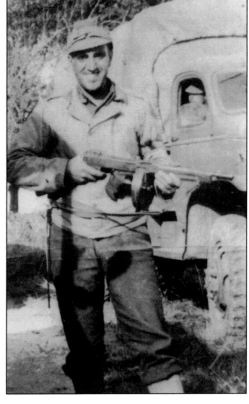

Sgt. Anthony Della Bella was born on July 14, 1916, the son of Ciro ("Jerry") and Assunta ("Susie") Della Bella. He had four sisters and two brothers. The family moved to Montvale in the 1930s and established the well-known restaurant Jerry's Villa, where he worked before going into service. He was 29 years old, a technician third grade (sergeant) in the 4th division of the 8th Army Infantry, when he was killed in action in Germany on February 2, 1945. (Courtesy of Jerry Della Bella.)

Cpl. George Michael Smyrychynski, a life-long resident of Montvale, was born August 7, 1943, in the house in which he grew up at 105 North Kinderkamack Road. He was the fifth of eight children—seven boys and one girl—of James W. and Lillian (Walters) Smyrychynski. Like his brothers, he is remembered by many residents as their newspaper carrier. He graduated from Pascack Valley High School in June 1960. He was a 23-year-old machine gunner with the rank of corporal when he was killed in action by a sniper's bullet near Da Nang, Vietnam, on October 13, 1966. A street in Montvale is named in his honor. Five of his six brothers also served in the military. (Courtesy of Jacquie Smyrychynski.)

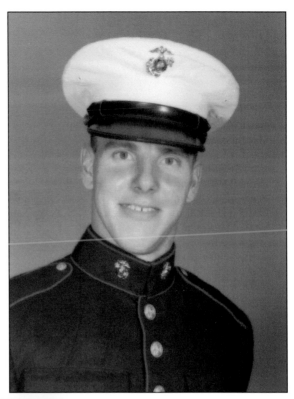

Specialist David William Brooks was born February 7, 1945, the only child of Frederick W. and Jessie Brooks. He had lived in Glen Rock, New Jersey, and graduated from Glen Rock High School in 1963, where he was an honor student and varsity athlete. The family then moved to Montvale. He was drafted into the Army on July 14, 1967. He was a specialist fourth class in Company B, 1st Battalion, 25th Infantry Division when he was killed in action on November 7, 1968, in Vietnam at the age of 22.

Cpl. Kevin Richard Humphrey was born October 15, 1951, in Teaneck, New Jersey, the son of William E. and Lorraine Humphrey. Although he was living in Park Ridge, his hometown of record when he enlisted, Kevin spent 15 of his 19 years in Montvale. He was a 1969 graduate of Pascack Hills High School and joined the US Marines after graduation. He served in Vietnam from January 27, 1970, until November 5, 1970, when he was killed in action. A plaque and tree honoring Lance Corporal Humphrey were dedicated in 2005 at Pascack Hills High School. (Courtesy of the American Legion.)

Pfc. John Joseph Pall was born in Teaneck, New Jersey, on January 5, 1944. His hometown of record was Montvale, as he was living there when he joined the Army. He grew up in Bergenfield, Bergen County, New Jersey, and graduated from Bergenfield High School. He was 23 years old when he died on April 2, 1978, as a result of multiple fragmentation wounds received from hostile ground fire. He was survived by his wife, Barbara, who at the time of his death was living in Bergenfield and expecting a child. The former Thames Park in Bergenfield was renamed John Pall Park.

Sgt. Paul Everette Paquin was born on May 3, 1949, in Connecticut. His family then moved to Spring Valley, Rockland County, New York, where he graduated from high school. His hometown of record is Montvale, New Jersey, as he was living there when he enlisted. He had four sisters: Karen, Donna, Ellen, and Paula. Paul served in the US Army with Company A 1/22 Infantry 4th Division and attained the rank of corporal. His tour in Vietnam began September 12, 1969, and he died in an accident in Bình Định, Vietnam, on June 27, 1970, at the age of 21. He was posthumously promoted to sergeant. (Courtesy of Paula Paquin.)

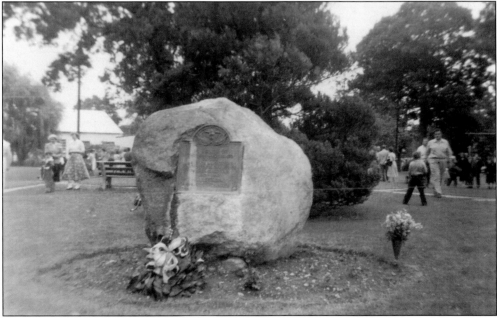

For many years after the World War II honor roll was taken down, the only war memorial in the borough was the 1921 Soldiers and Sailors monument in the south park. When the new monument was built in 1988, the plaque was removed from the boulder and installed on the back of that monument. It reads, "In honor of the men who served in the army or navy of the United States of America in the World War 1917–1919 / This tablet is erected by the Borough of Montvale" (see page 98).

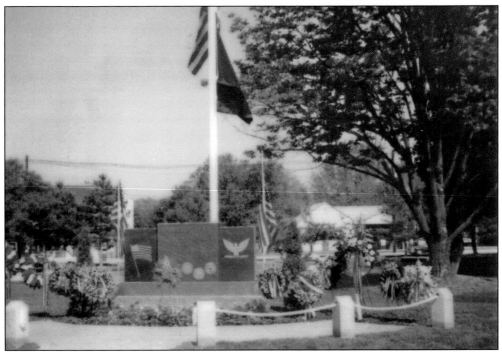

On Memorial Day 1988, on the northwest corner of Kinderkamack Road and East Grand Avenue, the new Borough of Montvale Veterans' Memorial was dedicated. On the reverse of the monument are the names of the men and women who lived in Montvale either before or after their service and participated in the various conflicts. There are 28 from World War I, 199 from World War II, 25 from Korea, 81 from Vietnam, and 6 from the Persian Gulf. Lt. Col. Edward Ballanco, who served in the Persian Gulf; his father, Sgt. Edward T. Ballanco, who served in World War II; and grandfather Julius Ballanco, who was an MP in World War I, are listed there.

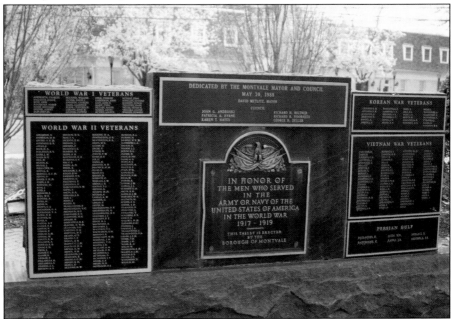

Eight

THEY ALSO SERVE

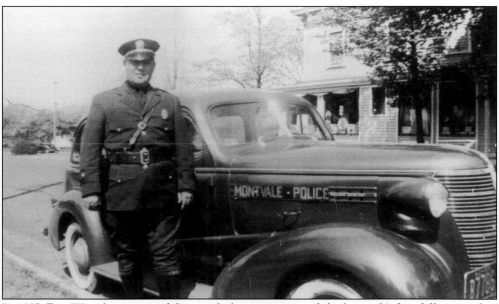

In 1937, Eric Wesselman, one of the marshals, was appointed the borough's first full-time police officer. He was paid a salary of $1,800 a year. He also had assistance from two part-time marshals. He is seen here on Grand Avenue across from the general store and near the police department (also known as the police booth).

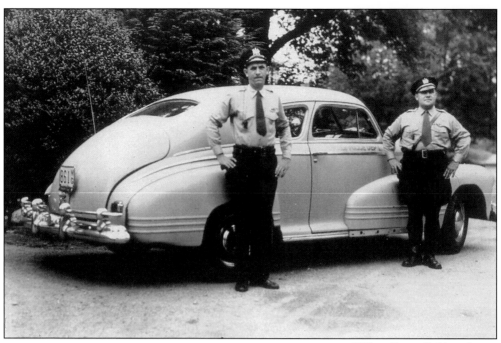

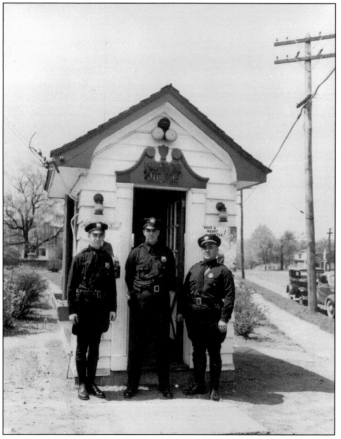

Officer Jones (left) and Chief Wesselman pose with their new Pontiac purchased from John Tomasini at Montvale Auto Sales at the end of 1942. The sale was completed quickly as Tomasini had received a letter saying no new cars could be sold in 1943 due to the war. It was purchased for $617.25 with a trade-in.

The police force was now up to three; from left to right, officers George Jones, Theodore Costos, and Eric Wesselman stand in front of the police booth. Notice electricity is now connected to the booth, and a neon sign over the door identifies it as Montvale Police. This photograph was likely taken in 1940 or 1941.

In 1942, they were back to two full-time police officers: Chief Wesselman and officer Jones (left to right in front of the others). Fourteen auxiliary policemen were appointed in that year to serve the duration of the war. Also, in 1942, the police department was given permission to use the vacant School No. 1 on Summit Avenue as police headquarters, auxiliary police training, and records court.

In 1962, Chief Jones had two other senior officers—Lt. Jack Hanna to his right and Capt. George Hanna to his left. In the back row between Jones and Hecker with a white hat is officer Tony Scarengella. All three men—Hecker, Hanna, and Scarengella—would at one time serve as police chief. Some of the people in this picture were crossing guards; there were only six salaried officers at the time.

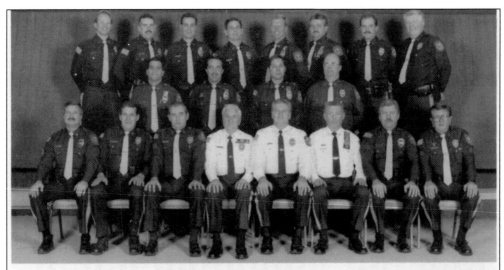

Seated: Sergeants Robert Gebhardt, Stephen Casale, Fred Parodi, Lieutenant James Ewings, Chief Joseph Marigliani, Captain Michael O'Donovan, Detective Sergeant James Frederick, Sergeant Robert Monk; Second Row: Detective David DiBlasi, Police Officers Bruce Piatt, Byron Marzan, James Whitney; Third Row: Police Officers Denis Murphy, William Tierney, Joseph SanFilippo, Jeremy Abrams, Greg Hanna, Bruce Czesniewski, William Stachnick, Nimrod Goering; Not Pictured: Police Officer Donald Boman, Council Liaison Patricia Byrne.

Officers on the Montvale Police Department in 1994 include, from left to right (in white shirts) Lt. James Ewing, Chief Joseph Marigliani, and Capt. Michael O'Donovan. In the third row, third from left, are Joseph San Filippo (chief from 2018 to today) beside Jeremy A. Abrams (chief 2012 to 2018). In 1994, there were 21 police officers, and in 2019, there were 25 police officers in the department.

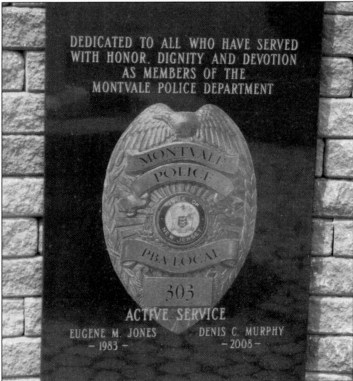

This police memorial is located outdoors near the police officers' entrance to the municipal complex. It is dedicated to policemen Eugene M. Jones and Dennis C. Murphy, who died while in active service. (Courtesy of Jesse Hopper.)

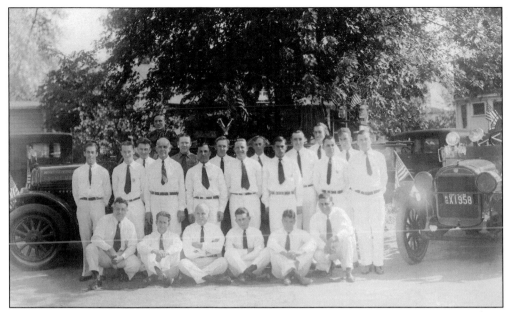

In 1932, the firemen posed in their dress white uniforms next to their trucks. Most men in those days had a pair of white flannel trousers and a white shirt, so the "uniform" was supplied by the members.

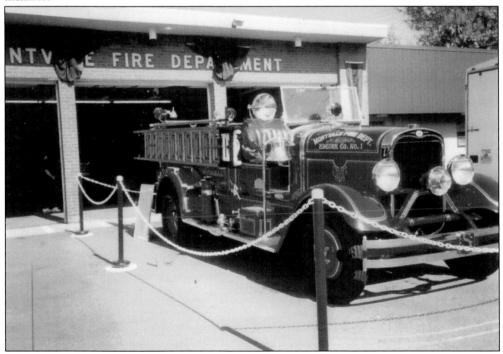

In 1935, the borough purchased a 600-gallon Seagrave pumper. When it was taken out of service, it was donated to the Fireman's Home and Museum in Booton, New Jersey, and was on display for many years. In 1994, it was determined that the Seagrave was no longer being displayed. It was returned to the town and restored by the firemen in time to celebrate the borough's 100th anniversary. It is the pride of the department.

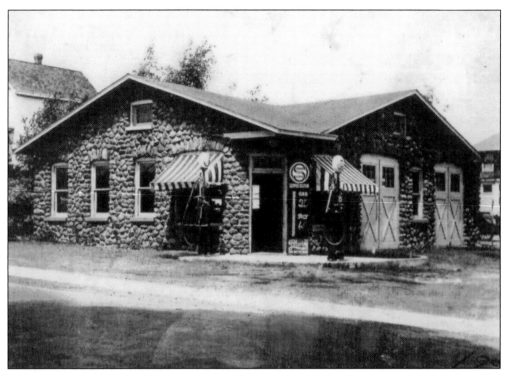

The Montvale Fire Department was chartered in October 1924. At the same time, it bought its first truck, a 350-gallon triple-combination pumper. Colligon Garage, on what is now Kinderkamack Road and Pearl Street, was the location of the first firehouse. It was rented from Collignon until 1954, when the Collignons were unable to continue the lease.

In 1954, with the Collignons no longer able to house the firetrucks, it was decided to build a new firehouse on Memorial Drive. The original three-bay firehouse was completed in 1955. Two other bays to the west of the three original bays were added over the years. In 1962, the Montvale Fire Reserve (Juniors) was formed, one of the first in Bergen County.

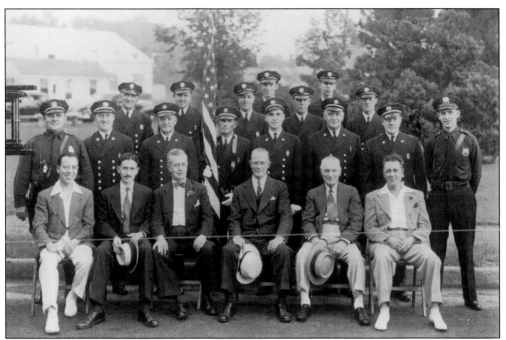

In 1944, when Montvale celebrated its 50th anniversary, the fire department posed for pictures. The firemen are seen here on Grand Avenue between the two parks. The two men on either end of the first row are police officers. The men out of uniform seated are members of the mayor and council. Below, the Fire Ladies' Auxillary poses in the center of the park in front of "the Lady." They had been formed in 1937 when Park Ridge, Montvale, and Pearl River hosted the New York/New Jersey Firemen's Parade. The auxiliary's main duty was to provide aid, like hot coffee, soup, or blankets while the men were fighting fires.

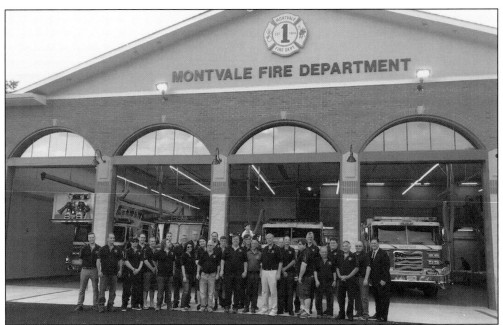

In October 2018, the brand-new, state-of-the-art Montvale Fire Department was dedicated. It had taken more than two years from the time the old building was torn down until the new building was dedicated, though the fire trucks had been moved in several weeks before. There was a fine rain falling for most of the outdoor ceremony, but that did not put a damper on the occasion. The trucks were removed from the station, as tables and chairs for a dinner were in the truck bays, and the people began to gather. Later, the members and officers of the department posed with their new golf shirts for a picture in front of the new firehouse.

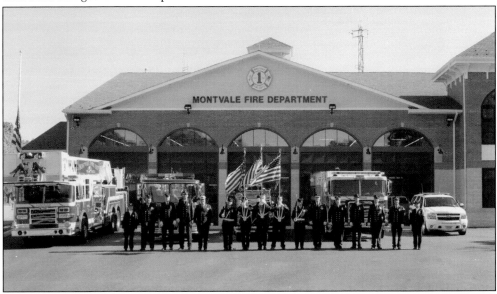

On Memorial Day 2019, some of the members of the Montvale Fire Department and Ladies Auxillary posed in front of their vehicles at the new firehouse. According to Chief Geoffrey Gibbons (white hat) there were 35 active members, five juniors, and ten Ladies Auxiliary members of the department in 2019. (Courtesy of Jesse Hopper.)

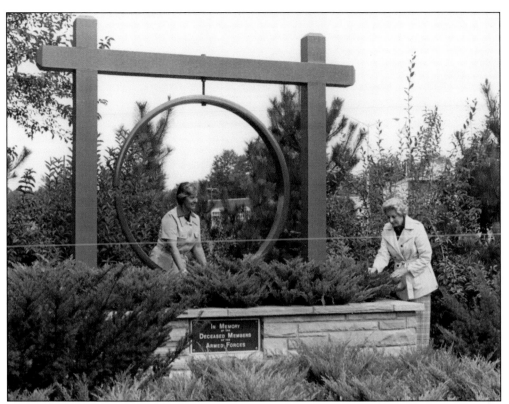

In the late 1950s, several women in Montvale formed a chapter of ACTION, which stands for "American Council To Improve Our Neighborhoods." Each year, the group raised money for a special project. Over the years, it financed many projects, including refurbishing the fire gongs, as seen here. They also raised money for a "Welcome to Montvale" sign, a cupola and clock on the borough hall, and a children's playground, and also bought the materials for the fountain in the center of town, along with many other projects. In 1967, the group received a thank-you letter for their efforts from Lady Bird Johnson, wife of Pres. Lyndon B. Johnson. ACTION disbanded in the late 1980s

THE WHITE HOUSE
WASHINGTON

November 29, 1967

Dear Mrs. Benjamin:

Thank you so much for your letter telling of the fine activities of "Montvale Action."

I was delighted to learn of your projects to enhance your community, for the best place to begin making improvements is in our home towns where the impressions of our children are nurtured.

All across the Nation citizens and civic officials are realizing that attractive surroundings are an asset to business and new growth, as well as providing a more pleasant and healthful way of life, and they are taking steps to spruce up their communities.

I hope that your group will continue your fine program, and you have my best wishes for success.

Sincerely,

Lady Bird Johnson

Mrs. Lyndon B. Johnson

Mrs. Donald M. Benjamin
16 Sunnyside Drive
Montvale, New Jersey 07645

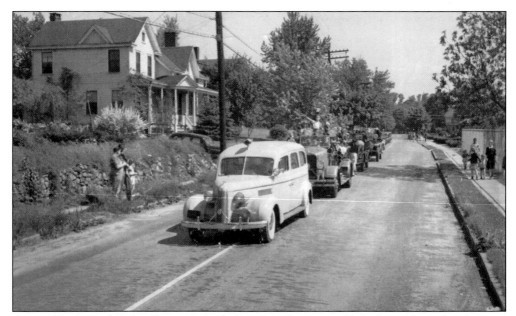

Originally, the Park Ridge Firemen's Ambulance Corps was established in 1939 with volunteers as attendants. Its first ambulance was a La Salle, seen here leading the Park Ridge trucks in the 1939 parade. In 1959, volunteers from Montvale and Woodcliff Lake joined, and the name was changed to Tri-Boro Ambulance Corps. (Courtesy of Herbert Syrett.)

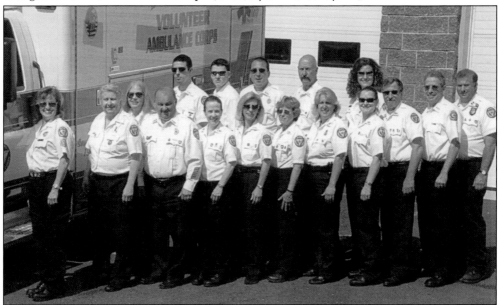

In 2013, members of the Tri-Boro Volunteer Ambulance Corps posed in front of their building to celebrate 75 years of service. From left to right are (first row) Elaine Vercellone (Montvale), Josephine Higgins, Al Nagy (Montvale), Sue Kiley, Judy Herman, Jodi Ludwig, Heather McGee (Montvale), Michelle Micali, Thomas Bolella, Mark Kastan (Montvale), and Joe Hughes (Montvale); (second row) Pam Daniels, Thomas Hughes (Montvale), Corey Reiner, Steve Bressler, Mike Jewell, and Theresa Cudequest (Montvale). McGee, Vercellone, and Cudequest have all served as presidents, and Al Nagy is the longtime treasurer. (Courtesy of Tri-Boro Volunteer Ambulance Corps.)

Nine

Last Stop in New Jersey

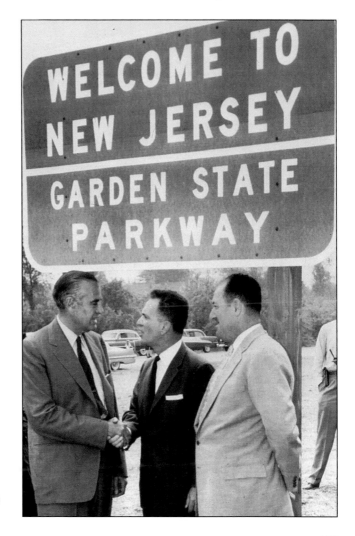

On August 30, 1957, the Garden State Parkway and the New York Thruway became connected. Shown here celebrating are, from left to right, New York governor Averell Harriman, New Jersey Turnpike director D. Louis Tonti, and Montvale mayor George Huff. Montvale would never be the same.

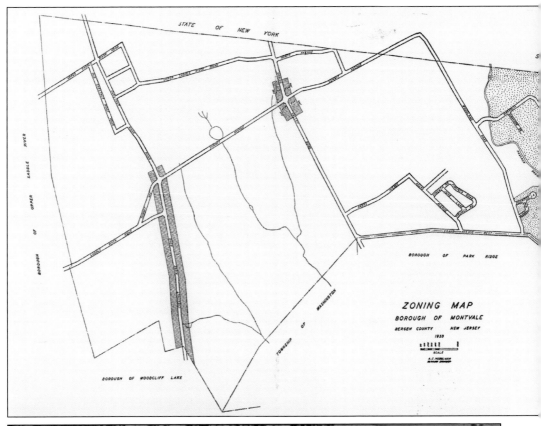

Benjamin Moore has been in Montvale since 1972, longer than any other company. Originally located on Chestnut Ridge Road, it is now at 101 Paragon Drive. The company has been manufacturing paints since the late 1880s and is a subsidiary of Berkshire Hathaway.

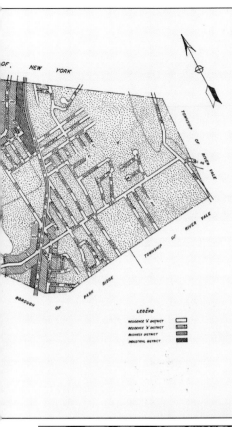

One of the best ways to realize how being the last stop on the Garden State Parkway (GSP) in New Jersey changed Montvale is to look at a 1953 zoning map of the borough. Notice how rural the western part of town was. Note too that Grand Avenue stopped at what is now the intersection of Spring Valley Road and Grand Avenue. It was not until four years later that Grand Avenue Extension was constructed to link Grand Avenue with the northbound exit of the GSP. Clever planning by borough officials opened up the land for Office and Research (O&R) and Specialized Economic Development (SED).

Mercedes-Benz was one of the first and largest international headquarters to make Montvale its home. The company came to Montvale in 1972 and had over 1,000 employees on a 37-acre campus in 2015 when it announced it was moving to Atlanta, Georgia. Other firms, such as A&P, BMW, and Toys R Us, have also moved on. Some of its building have been repurposed by other firms, and some have been demolished and replaced by multiple housing units.

This aerial view of the Garden State Parkway was used in a 1974 booklet produced to encourage business and potential homeowners to move to Montvale. The large building at top was then Lehn and Fink. DePiero's Farm is at lower right.

The Lehn and Fink building, pictured here in the 1974 promotional booklet, was headquartered in Montvale for many years. When the company decided to move, Toys R Us purchased the building. It was only vacant for a short time when it was quickly purchased by Memorial Sloan Kettering. In 2018, after completely rehabbing the building, a state-of-the-art cancer treatment center opened there. (Below, courtesy of Jesse Hopper.)

KPMG is one of the world's leading professional services firms, providing innovative business solutions and audit, tax, and advisory services to many of the world's largest and most prestigious organizations. KPMG is widely recognized for being a great place to work and build a career. The firm employs approximately 3,000 professionals on its 360,000-square-foot central campus in Montvale and has been in Montvale since the early 1970s. (Courtesy of Susan E. Kenney.)

Western Union Financial Services is at 100 Summit Avenue in Montvale. It specializes in the development of international and commercial businesses. (Courtesy of Jesse Hopper.)

The Courtyard by Marriott is another building that has been repurposed. Built in the early 1970s as a Ramada Inn, several years ago, it was remodeled into an upscale hotel. Located at 100 Chestnut Ridge Road, its signature restaurant, Fire and Oak, an American bar and grill, attracts both hotel customers and local diners. (Courtesy of Jesse Hopper.)

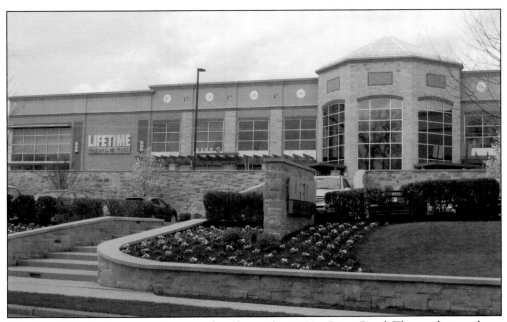

Lifetime Athletics is an upscale gym and spa located at 10 Van Riper Road. The spa features huge indoor and outdoor pools, a yoga studio, cycle studio, and much more. (Courtesy of Jesse Hopper.)

Sharp USA, a former Japanese firm, is the latest corporation to move to Montvale. The company has reclaimed a building, as the former Paragon Credit Union Building is now its new home. Prior to its move to Montvale, it was headquartered in a much larger building in nearby Mahwah. (Courtesy of Jesse Hopper.)

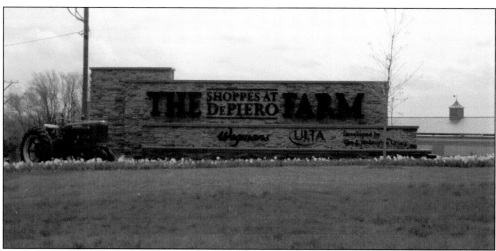

Though many Montvale residents were sad to see the DePiero's Farm close, they looked forward to the opening of the Shoppes at De Piero Farm. They were not disappointed; the huge Wegmans grocery store is the first in northern New Jersey. There is also a Starbucks, Ultra Beauty, AT&T, Chipotle, and Beets, a juice bar.

Ten

ANNUAL EVENTS AND CELEBRATIONS

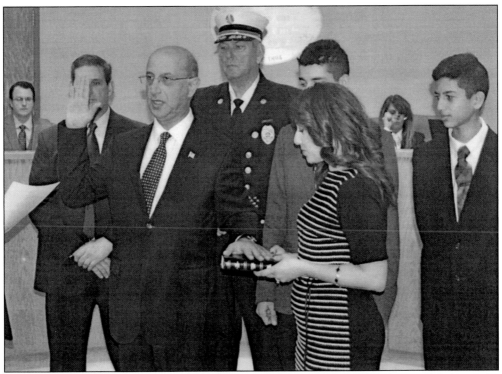

The beginning of every year starts with the borough's Reorganization Meeting and the swearing in of the newly elected officials and officers. On January 4, 2016, Mayor Michael Ghassali is being sworn in as his wife, Mary Ann, holds the Bible. In the background are (from left to right) police chief Jeremy Abrams, fire chief Clint Miller, and the couple's sons Ellie and Danny. (Courtesy of Michael Ghassali.)

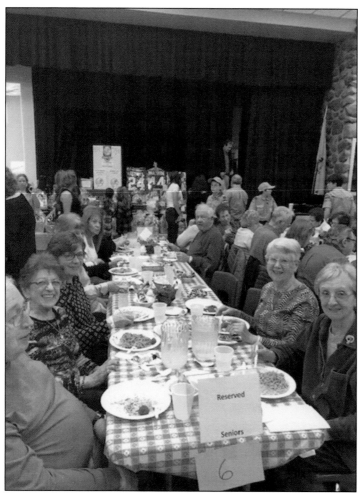

In March, the community spaghetti dinner is put on by Troop No. 334 of the Montvale Boy Scouts. The dinner held at Fieldstone School is attended by hundreds of people annually. They come not only for the pasta, but also for the wonderful raffle baskets. The money raised goes to the Boy Scouts and other local charities. Here, members of the Montvale Senior Club enjoy their dinner. (Courtesy of Judith Santos.)

The annual opening day parade and ceremony of the Montvale Athletic League is held in April. The parade of baseball and softball players and their coaches march down Memorial Drive, terminating at the Carl Ciccarello Major League Field. Pictured here in 2009, Mayor Roger Fyfe (a former Montvale Athletic League president) provides encouragement to the teams and coaches gathered around the field.

Since the 1960s, the Montvale firemen have hosted a Mother's Day pancake breakfast. The firetrucks are moved from the firehouse, and dozens of tables are set up. Mothers and their families enjoy a delicious breakfast prepared by the firefighters featuring pancakes, sausage, homemade doughnuts, juice, and coffee. From 500 to 800 meals are served each year. Here, Jeff Ballanco (left) and Craig Miller (right) are starting up the grill.

Prior to the Memorial Day parade, a memorial service is held at the veterans' monument on the corner of Kinderkamack Road and Grand Avenue. Prayers and speeches honor those who have served their country, and various civic groups decorate the monument. Pictured here in 1988 are Gold Star parents Lillian and James Smyrychynski with chief of police Joseph Marigliani.

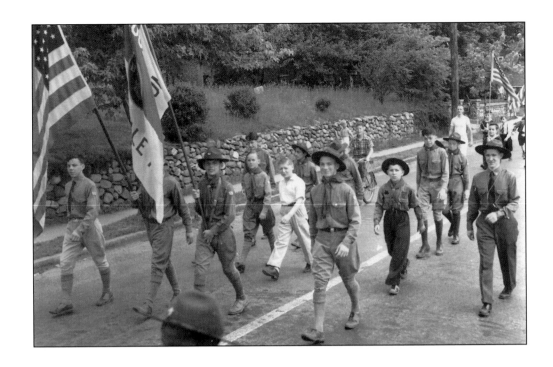

Every year, a Tri-Boro Memorial Day Parade proceeds from Montvale through Park Ridge to Woodcliff Lake. Until recent years, Montvale and Woodcliff Lake alternated starting the parade. Now the parade always begins in Montvale. Above, in 1939, the Montvale Boy Scouts had their picture snapped while marching in the parade. Below, in 1943, the Montvale Brownies (right) and Girl Scouts (left) lined up in front of the Montvale station ready to step off. For more than 75 years, the Girl Scouts, Brownies, Boy Scouts, and Cub Scouts have been honoring America's heroes by their participation, as they will for years to come. (Above, courtesy of Herbert Syrett.)

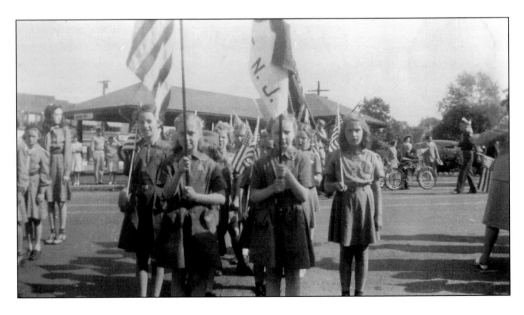

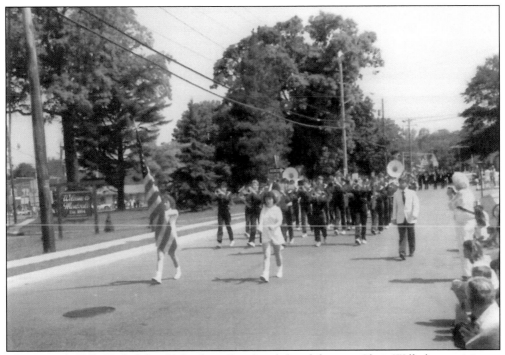

The Pascack Hills High School Marching Band with band director Chris Wilhelm participates in the Tri-Boro Memorial Day Parade in 1988. They are leaving Montvale on the two-mile march to Woodcliff Lake.

One of Montvale's longest traditions is the eighth grade trip to Washington, DC, prior to graduation. In the early years, credit for defraying the cost of the trip was earned by serving on the safety patrol. The class of 1955 had a group picture taken in front of George and Martha Washington's Mount Vernon home. Note the purses and cameras in the foreground. (Courtesy of Bob O'Leary.)

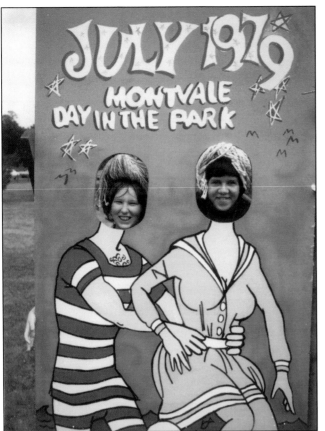

In June, people gather for the annual Day in the Park, begun in the early 1960s by ACTION, the women's organization. It is now run by the recreation commission. Memorial Drive is closed to vehicular traffic, and the celebration begins. The day features many different rides and a concert; it concludes with a fabulous fireworks display watched by hundreds seated on the lawn behind Memorial School. At left, two youngsters have their picture taken. Below, in 1992, a boy tries out the climbing wall, one of many rides and attractions, while a father tries to interest his toddler in a football.

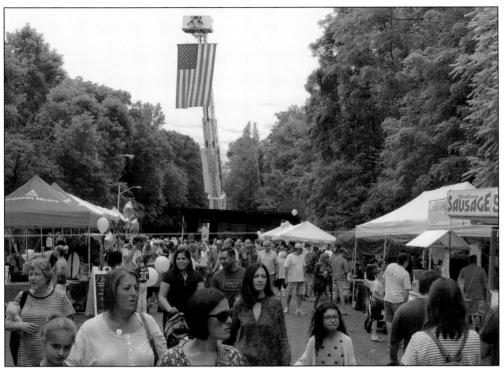

Since 2011, the Montvale Chamber of Commerce has been sponsoring the Montvale Chamber Street Fair on Paragon Drive. It seems to grow bigger and better every year, attracting thousands of visitors. There are many rides, hundreds of vendors, special arts and crafts sections, a children's area, a community section, food courts, and continuous live entertainment all day. Funds raised by the fair are donated to local charities. In 2018, the chamber donated the Freedom Bell on top of the new firehouse, which was dedicated to the firefighters who died on September 11, 2001. (Both, courtesy of Tom Hartel.)

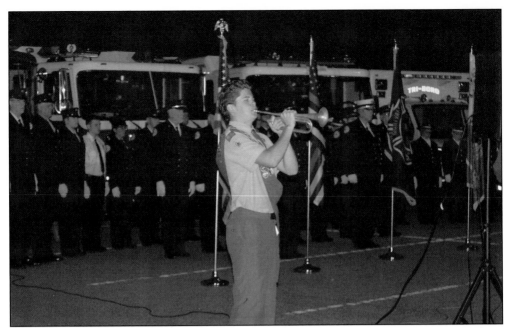

On the anniversary of 9/11, Montvale citizens gather for a candlelight memorial service for those who lost their lives on that fateful day. Although no residents of Montvale were lost, because Montvale is a suburb of New York City, many residents know someone or some family affected by the tragedy. The Montvale Fire Department plans to build a permanent 9/11 memorial using a piece of steel it recently obtained from one of the towers. Here, Boy Scout Frank Sott plays "Taps."

In December, the annual tree lighting and gift giving ceremony is held. Originally held in the park, in recent years the ceremony has moved to Memorial Drive. School choirs add to the festivities. The many donated gifts are given to the less fortunate in the area.

One of the longest traditions in Montvale is the arrival of Santa on the fire truck every Christmas Eve. Begun by the Montvale firemen in 1930 during the Depression, when many children received few if any presents, each child was presented with a stocking containing fruit, nuts, and candy. They still do, though now, they also receive a toy as well. The Fire Ladies' Auxiliary serves hot chocolate and pound cake to those awaiting Santa's arrival. In 1992, fireman Tom Powers got out his saw, and his wife Karen, her paintbrush—Santa's nine reindeer now adorn the fire truck. Montvale residents are truly grateful to the firemen who each year give up valuable family time on Christmas Eve to make such a memorable experience for the town's children.

Not only does Montvale have a tradition of celebrating with annual events, but it also has a tradition of celebrating. When New Jersey became 300 years old, Montvale celebrated the tricentennial. When the United States turned 200 years old, Montvale celebrated with an Old Fashioned Day in the park and a centennial parade. In 1944, in the midst of World War II, Montvale celebrated its 50th anniversary. Various events were planned, and the 40-page booklet *Borough of Montvale 1894 August 1944* was published.

In 1994, Montvale celebrated its 100th with even more events. A history of the borough, entitled *Borough of Montvale Centennial Journal*, was written by Richard Voorhees and is available for all to read on the Borough's website (www.montvale.org). Both books were invaluable in compiling this book to celebrate Montvale's 125th anniversary.

BIBLIOGRAPHY

Bailey, Rosalie Fellows. *Pre Revolutionary Dutch Houses and Families in Northern New Jersey and Southern New York*. New York, NY: William Morrow & Company, 1936.

Relics. Park Ridge, NJ: Pascack Historical Society, 1955–present.

Borough of Montvale New Jersey August 1894–1944. Montvale, NJ: Borough of Montvale, 1944.

Durie, Howard I. "The Sandstone Homesteads of Montvale Past and Present." *Relics*. Park Ridge, NJ.

Durie, Howard J. *The Kakiat Patent in Bergen County, New Jersey; with Genealogical Accounts of Some of its Early Settlers*. Pearl River, NY: Star Press, 1970.

Hopper, Maria Jean Pratt. *The Hopper Family Genealogy, Descendants of Andries Willemszen Hoppe(n) of New Amsterdam 1651–1658*. Lulu Press, 2005.

Jobson, Thomas W. "Dateline Montvale: Progress?" *Asbury Park Press*. December 18, 1977.

McMahon, Reginald, ed. *Historic Site Markers, New Edition with Supplement*. New Jersey: Bergen County Historical Society, 1996.

Montvale, NJ Memories Facebook page. Mike Furman, manager.

Vorhees, Richard. *Borough of Montvale Centennial Journal 1894–1994*. Montvale, NJ: Borough of Montvale, 1994.

www.montvale.org
www.njvvmf.org

DISCOVER THOUSANDS OF LOCAL HISTORY BOOKS
FEATURING MILLIONS OF VINTAGE IMAGES

Arcadia Publishing, the leading local history publisher in the United States, is committed to making history accessible and meaningful through publishing books that celebrate and preserve the heritage of America's people and places.

Find more books like this at
www.arcadiapublishing.com

Search for your hometown history, your old stomping grounds, and even your favorite sports team.